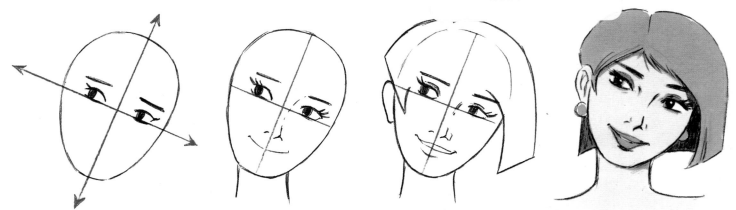

Figure It Out!
Simple Lessons, Quick Results
Essential Tips and Tricks for Drawing People

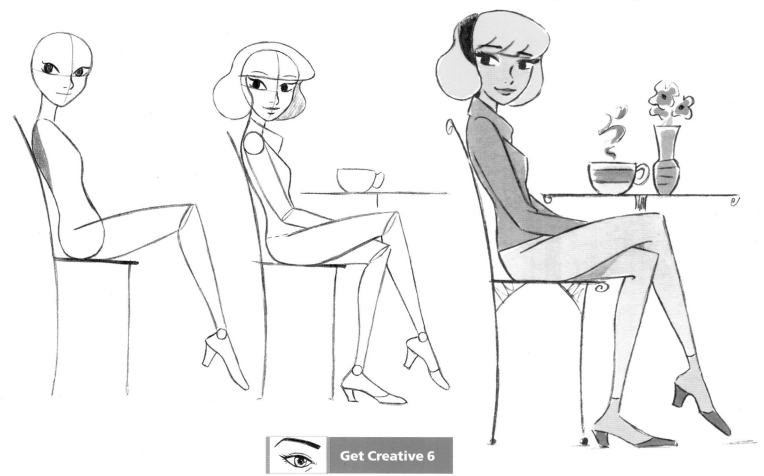

Get Creative 6

DRAWING WITH *Christopher Hart*

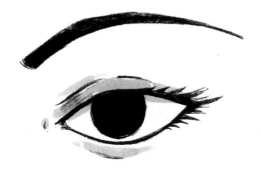

An imprint of **Get Creative 6**
19 West 21st Street
Suite 601
New York, NY 10010
sixthandspringbooks.com

Managing Editor/Senior Editor
LAURA COOKE

Art Director
IRENE LEDWITH

Assistant Editor
JACOB SEIFERT

Production
J. ARTHUR MEDIA

Vice President
TRISHA MALCOLM

Chief Operating Officer
CAROLINE KILMER

Production Manager
DAVID JOINNIDES

President
ART JOINNIDES

Chairman
JAY STEIN

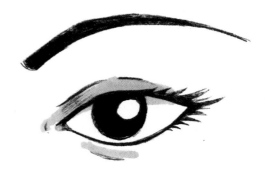

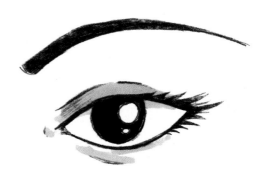

Cataloging-in-Publication data is available from the Library of Congress.

ISBN: 978-1-64021-024-0

Manufactured in China

9 10 8

First Edition

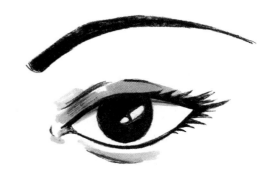

This book is dedicated to my wife, Maria, whose insightful comments are always so helpful.

christopherhartbooks.com
youtube.com/chrishartbooks
facebook.com/CARTOONS.MANGA

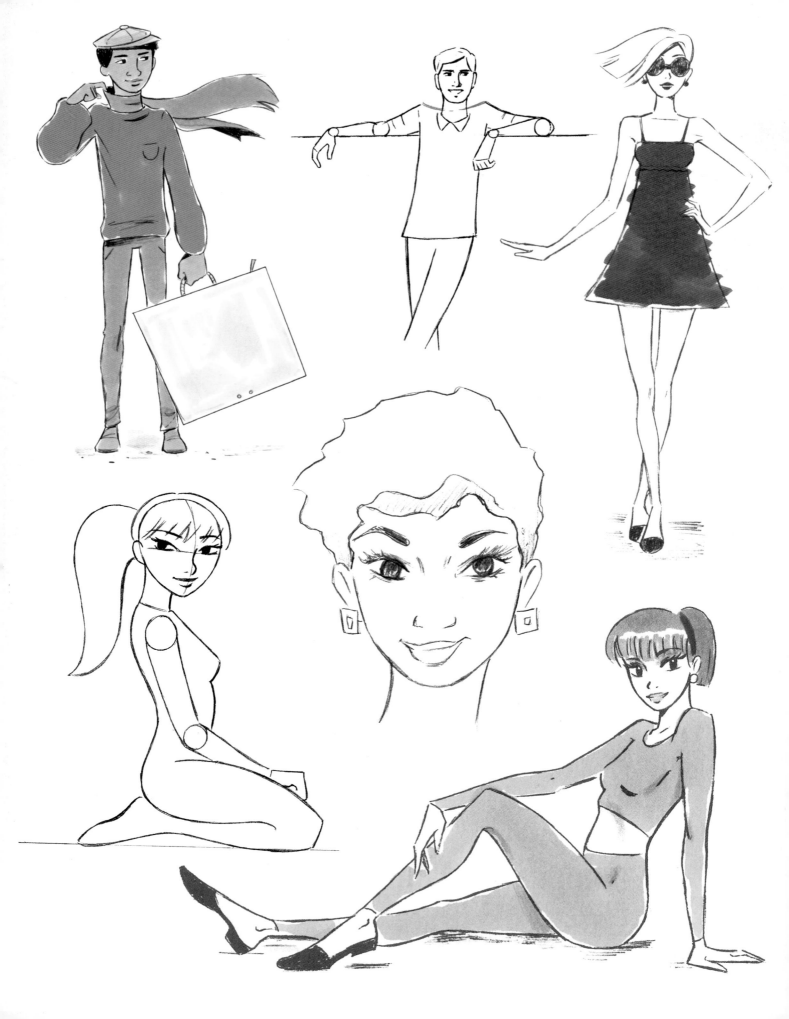

Contents

Introduction

Are you like most aspiring artists who struggle to find the right way to draw the head and body? Difficulties have a way of suddenly presenting themselves just as you're getting into your creative flow. So what happens? You try to plow past them. But using the same techniques that didn't work the first time still won't work the second or the third time. Unless you have the knowledge to solve the problems of figure drawing, making progress can feel like blasting through granite.

By using the tips, tricks, and techniques in this book, you will be able to draw the head and human figure while staying in your creative groove. The pages in this book are filled with solutions to the common drawing challenges that all artists face. Learning these techniques will easily raise your skills to a new level, and without much effort too.

Perhaps you've practiced consistently,

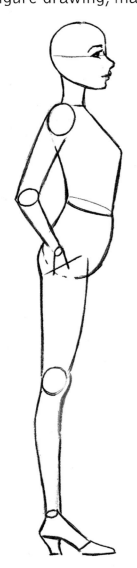
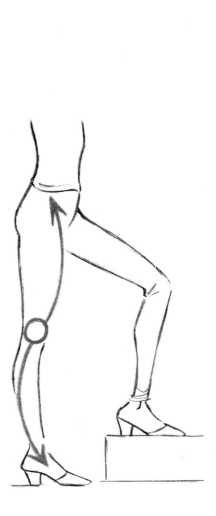
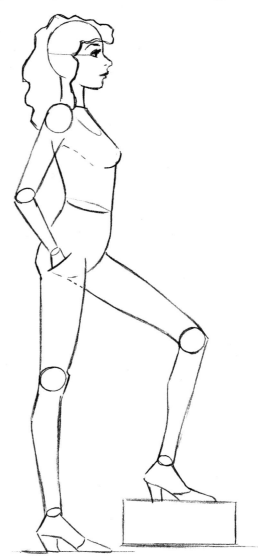

but have plateaued. This book will get you back into high gear with a generous supply of illustrated tips and hints. You'll be able to master techniques and subjects that you may have thought were beyond your abilities. The concepts in this book are as intuitive as they are practical. Art is about self-expression, but without the right tools, we can't express ourselves effectively. Here are the tools. Why not start today?

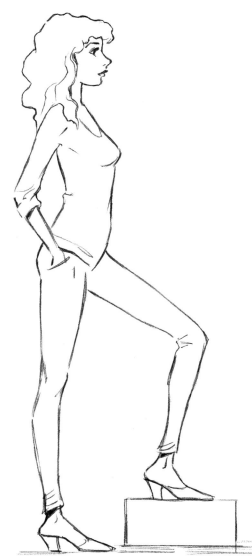

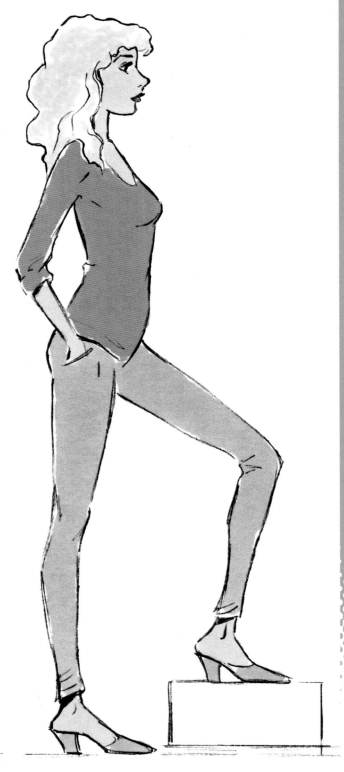

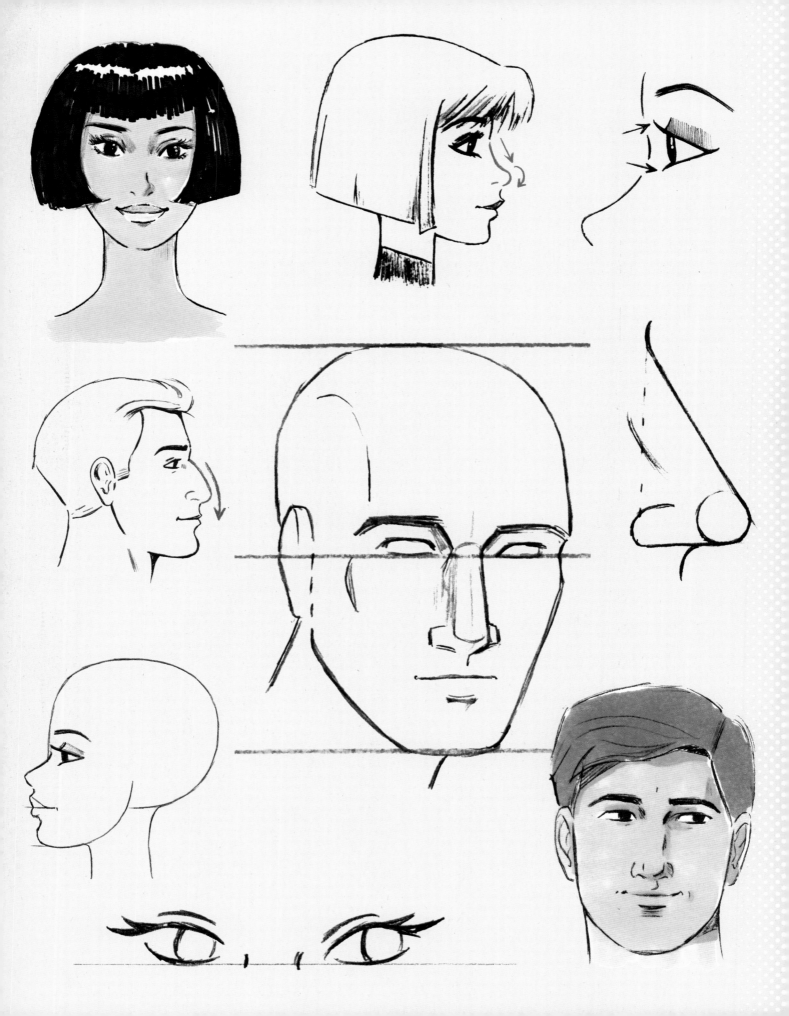

Start with Simple Concepts

All of the teachings in this book are highly practical. You can put them to use right away; you don't need to wait until you've mastered them. The most effective techniques for drawing are based on simple concepts. By establishing a clear construction in the first and second steps, the details will unfold naturally, making learning to draw deceptively easy. These lessons are also intuitive, which means that once you grasp an idea, you're likely to remember it. Everything is designed to give you the skills you've been working for.

Key Proportions of the Head: Front View

One important thing to know as you're getting started is how to prioritize all of the information out there about drawing. Among the many concepts for drawing the face, here's one to commit to memory: The eyes are located halfway down the head, as measured from top to bottom. That means the eyes will be drawn at the same level as the bridge of the nose.

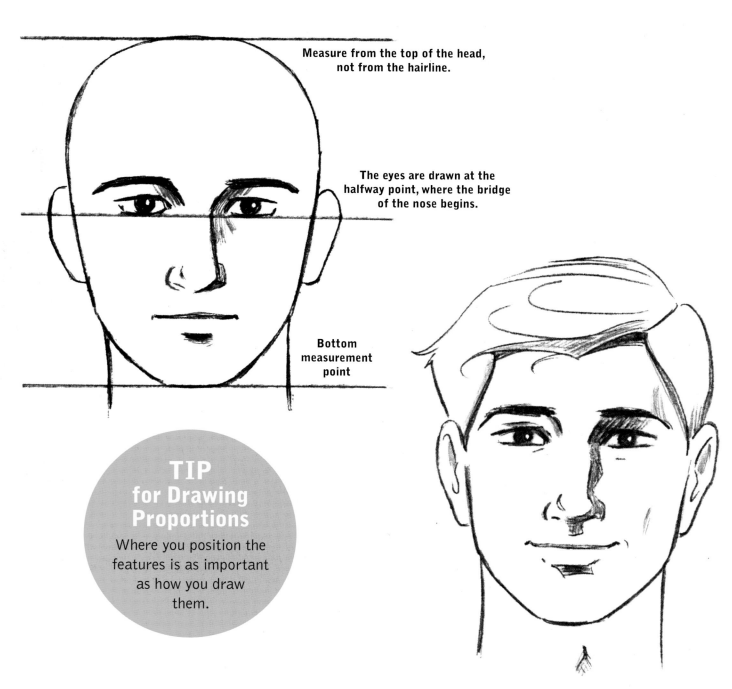

Measure from the top of the head, not from the hairline.

The eyes are drawn at the halfway point, where the bridge of the nose begins.

Bottom measurement point

TIP for Drawing Proportions

Where you position the features is as important as how you draw them.

12

Use Proportions for Other Angles

Once again, the eye line becomes a simple, but effective, organizing principle when roughing out the face. The proportions demonstrate that there's more forehead than most people assume. That's because it is mostly masked by hair.

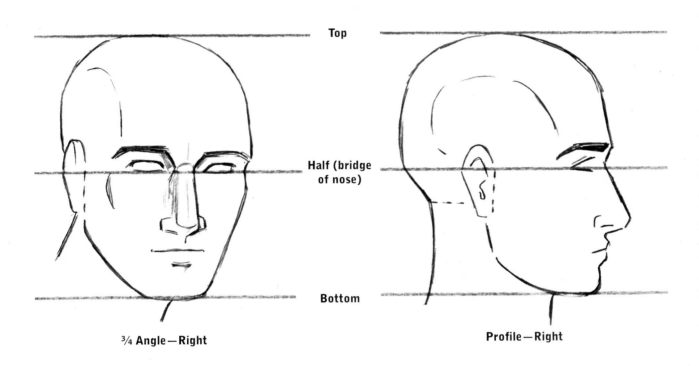

Top

Half (bridge of nose)

Bottom

¾ Angle—Right

Profile—Right

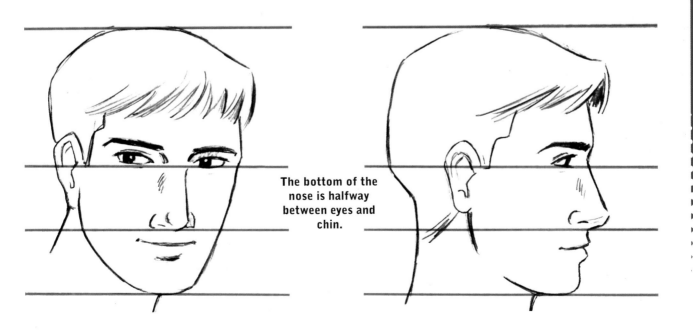

The bottom of the nose is halfway between eyes and chin.

13

Getting the Shape of the Head Right

The overall shape of the head is the foundation for drawing the face. We won't worry about drawing the features until we have this basic shape in place. This template will be used for all faces, both male and female. All we do is modify it to create individuals.

Man's Head

As you follow the steps, notice how each one builds on the one before it.

TIP
Changing and adjusting is the key to drawing.

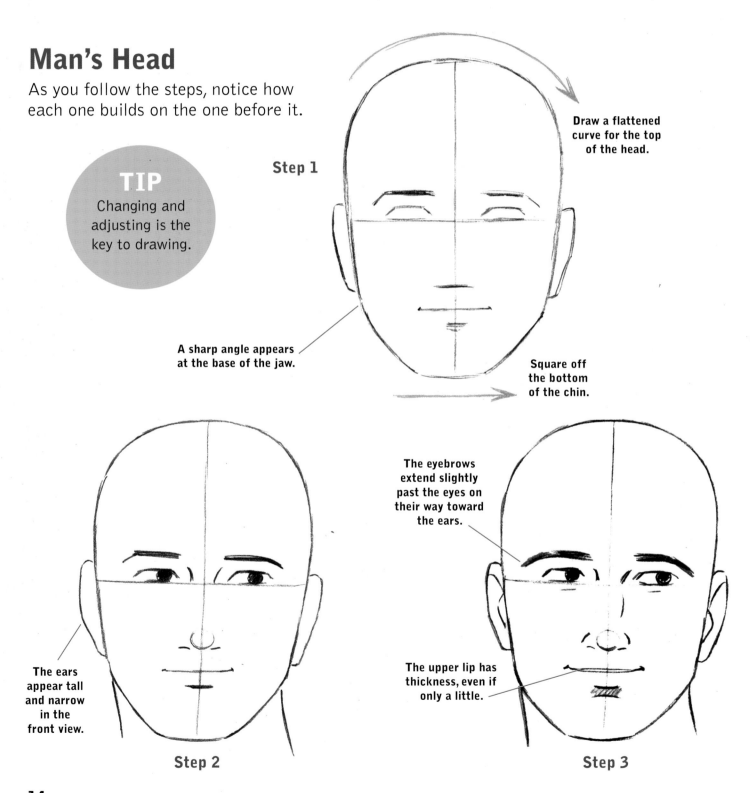

Step 1

Draw a flattened curve for the top of the head.

A sharp angle appears at the base of the jaw.

Square off the bottom of the chin.

The ears appear tall and narrow in the front view.

Step 2

The eyebrows extend slightly past the eyes on their way toward the ears.

The upper lip has thickness, even if only a little.

Step 3

The hair adds a bit of padding.

You don't need to draw both sides of the bridge of the nose.

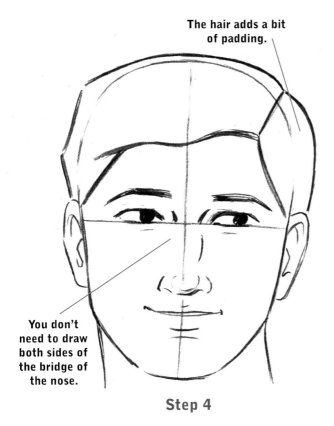

Step 4

Draw a few strands of hair to suggest a direction to the haircut.

Add a touch of shading to the side of the nose and below the lower lip.

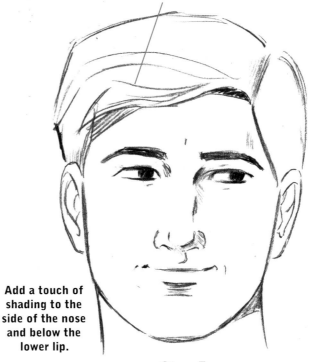

Step 5

Can You Guess?

What makes the eyes the most engaging feature of the face? It's the contrast that is created by black pupils against the whites of the eyes.

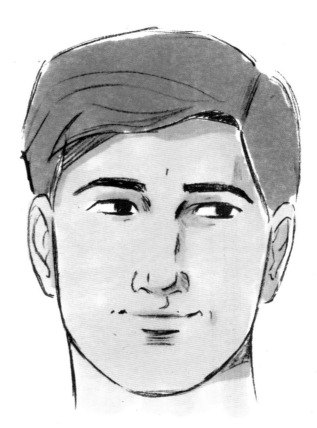

Step 6

15

Woman's Head—Front View

There are a few subtle differences to the female head shape, which can be created by narrowing and tapering it.

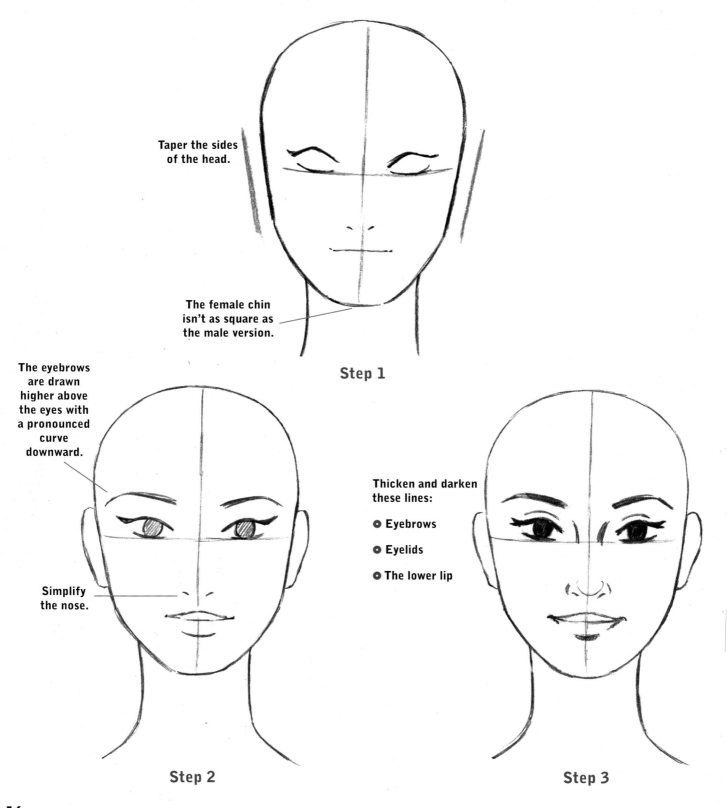

Taper the sides of the head.

The female chin isn't as square as the male version.

Step 1

The eyebrows are drawn higher above the eyes with a pronounced curve downward.

Simplify the nose.

Step 2

Thicken and darken these lines:

- Eyebrows
- Eyelids
- The lower lip

Step 3

Draw the bangs on a slight curve. Or, if you prefer a more severe style, lower the bangs and draw them with a straight line across the eyebrows.

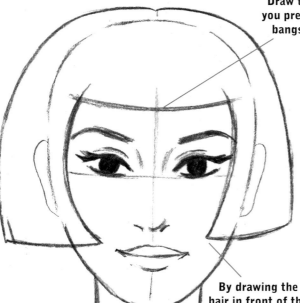

Sketch a few streaks of hair to suggest texture.

By drawing the hair in front of the face, you add an element of depth. This is called *layering*.

Draw eyelashes pointing upward.

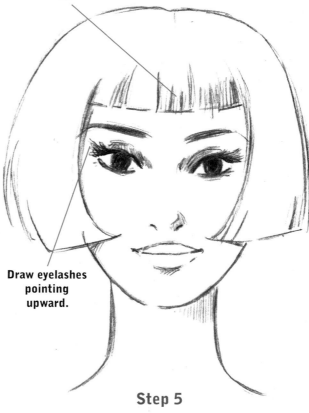

Step 4

Step 5

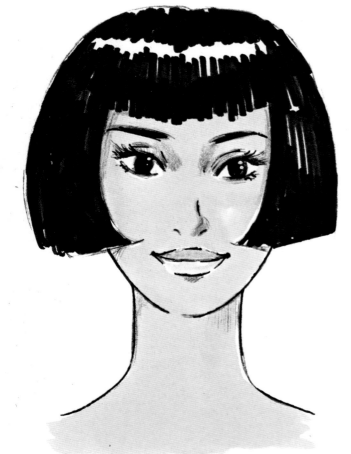

IMPORTANT TIP about Drawing Hair

If you begin your drawing by articulating each strand of hair, you'll be forced to draw every single strand to create a consistent look. Instead, indicate only a few streaks of hair as accents.

Step 6

17

Those Eyes!

No two eyes are the same, however, they're all drawn using the same principles. Once you learn these principles, you can modify the eyes to create any look. When you think of the eyes, think of them as a group that includes eyelids, eyelashes, the bridge of the nose, and eyebrows. You need each element to complete the look.

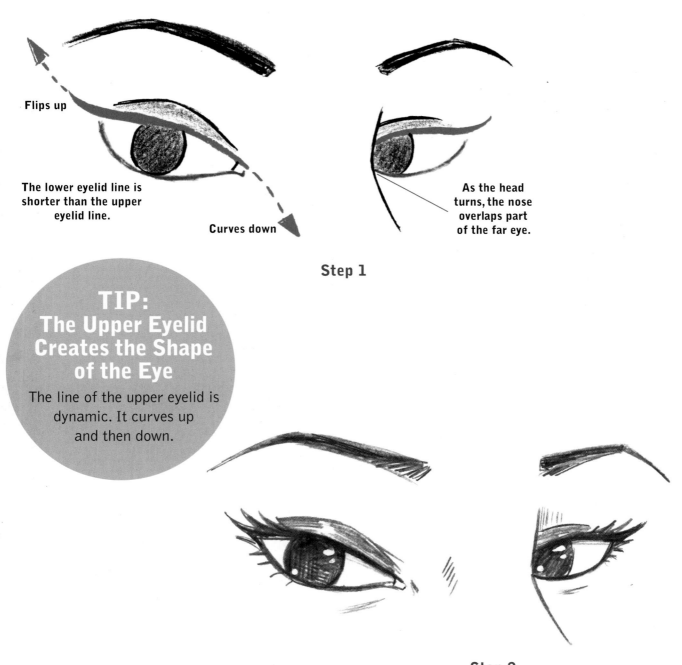

Flips up

The lower eyelid line is shorter than the upper eyelid line.

Curves down

As the head turns, the nose overlaps part of the far eye.

Step 1

TIP:
The Upper Eyelid Creates the Shape of the Eye

The line of the upper eyelid is dynamic. It curves up and then down.

Step 2

Draw the Eyes Step by Step

Let's start this series of steps by using the upper and lower eyelids as brackets. Draw both sets of eyelids first before adding the eyeballs. This will help you to match the left eye with the right eye.

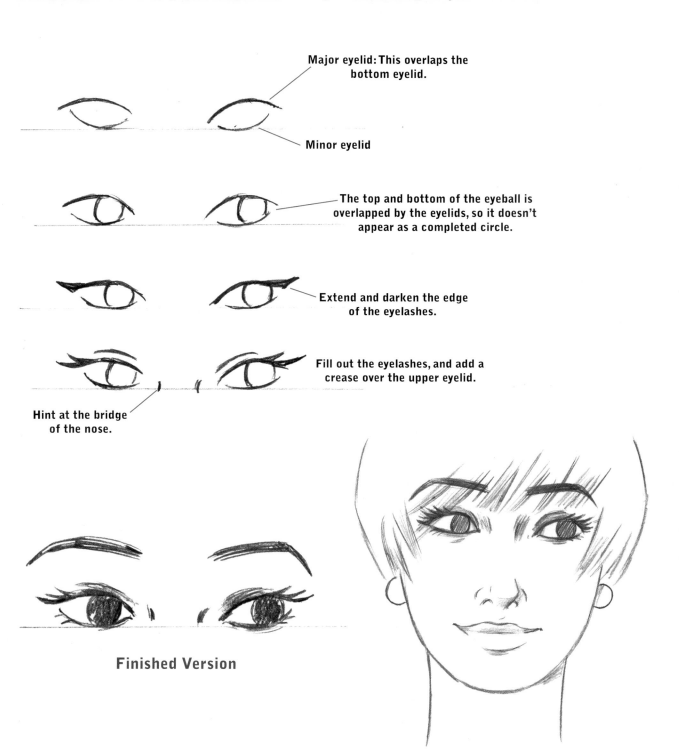

Major eyelid: This overlaps the bottom eyelid.

Minor eyelid

The top and bottom of the eyeball is overlapped by the eyelids, so it doesn't appear as a completed circle.

Extend and darken the edge of the eyelashes.

Fill out the eyelashes, and add a crease over the upper eyelid.

Hint at the bridge of the nose.

Finished Version

Applied to a Finished Face

19

The Three Basic Eye Shapes

Notice that each eye shape is different, but they all follow the guidelines we just reviewed for drawing the standard eye. There are many variations to the shape of the eye. The following three are popular types on which to base your variations.

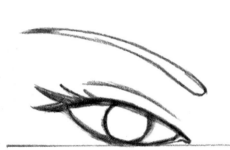

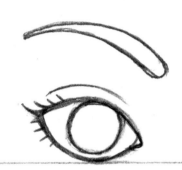

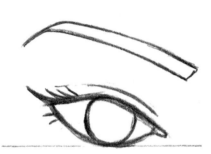

Slim

This style is long and thin with dramatic eyelashes. The eyebrow is typically drawn close to the eye. Notably, the upper eyelid is partially closed.

Round

The short and round shape makes the eyeball look large and bright. It's usually drawn with short eyelashes. It's a cheerful, alert look.

Regular

If there's a standard shape to the eye, this is it. It's round, but with a taper. Think of it as a combination of the first two types.

Eyelids and Expressions

Maybe you've never given eyelids much thought. Or maybe you think about eyelids all the time, and your friends have become worried about you. Either way, manipulating the shape of the eyelids is essential to creating expressions. They can be pulled left, right, up, or down or be stretched or compressed. Let's check out a few examples.

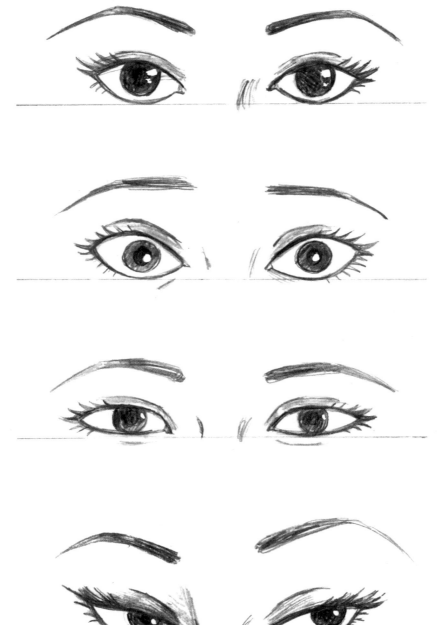

Normal

Evenly balanced. Allow the whites of the eyes to show below the iris.

Wide (Worried)

Raise the eyelids so that you can see the whites of the eyes above and below the iris. Keep the eyelashes short.

Narrow (Pleased)

The upper and lower eyelids narrow on the eyeball. These eyes work well with a smile.

Fashionable (Attitude)

Heavy eyelids overlap the eyeballs. Pull the eyes up at the ends. Shade the eyelids.

Eyelashes—The Finishing Touch

yelashes can create an appealing and even glamorous look. A few simple tips will show you how.

Draw a small line here to indicate the flap of the inner eyelid.

The eyelashes extend past the eye, making the line of the eyelid appear longer than it really is.

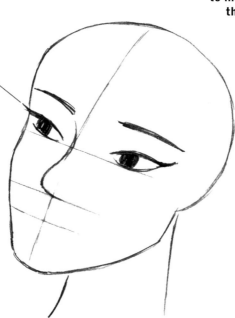

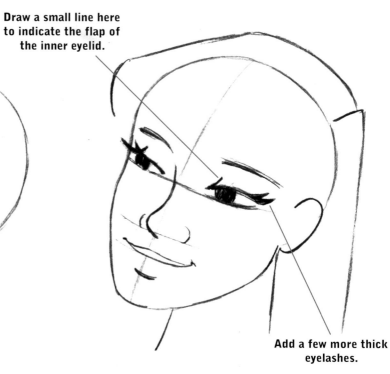

Add a few more thick eyelashes.

Shade the upper eyelids.

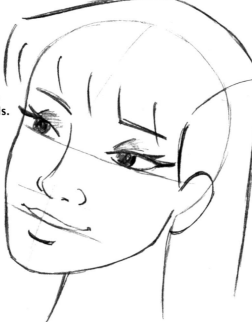

Erase a small area in each pupil to create a shine for a highlight.

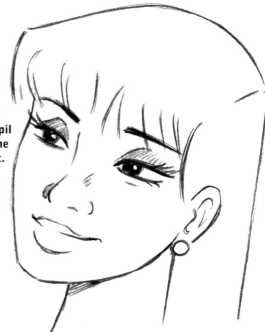

Putting It into Practice

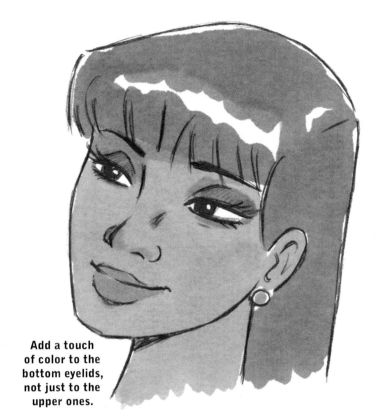

Add a touch of color to the bottom eyelids, not just to the upper ones.

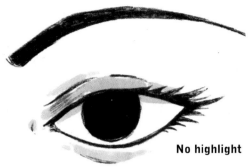

No highlight

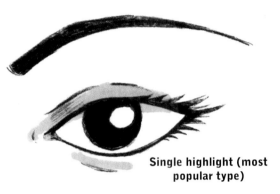

Single highlight (most popular type)

Adding Highlights to the Eyeball

It's the little dot of reflected light in each eye that adds a flicker of life. Before you draw an empty circle as a highlight, pause a moment. The highlight is actually a mini-design. As artists, we look for opportunities to express our creativity, even if it's with just a dot of light.

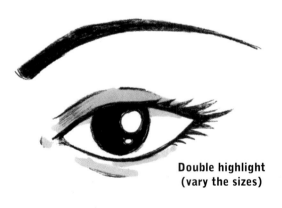

Double highlight (vary the sizes)

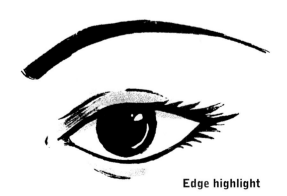

Edge highlight

Drawing Eyes in Profile

Here's a tip: Because the eye appears smaller in profile, accentuate the eyelashes to compensate.

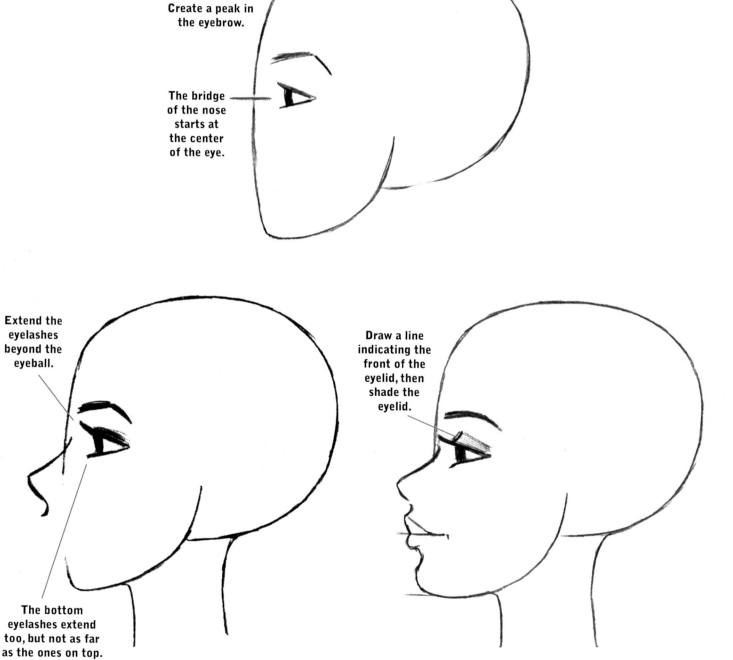

Create a peak in the eyebrow.

The bridge of the nose starts at the center of the eye.

Extend the eyelashes beyond the eyeball.

The bottom eyelashes extend too, but not as far as the ones on top.

Draw a line indicating the front of the eyelid, then shade the eyelid.

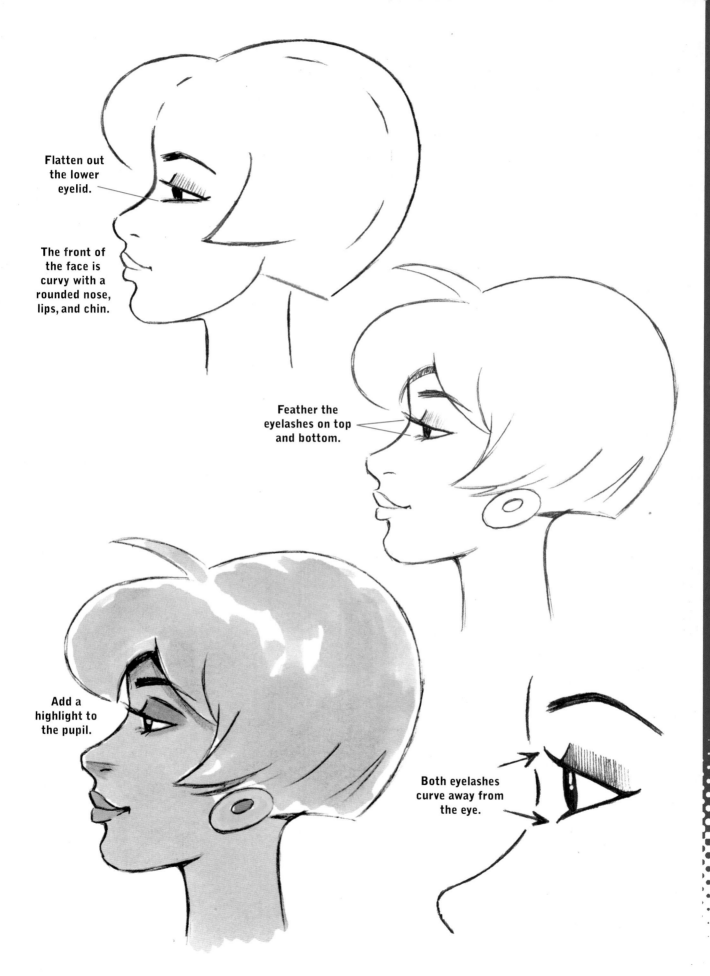

Flatten out the lower eyelid.

The front of the face is curvy with a rounded nose, lips, and chin.

Feather the eyelashes on top and bottom.

Add a highlight to the pupil.

Both eyelashes curve away from the eye.

Nose Types— Common Variations

The nose is the most complex feature of the face to draw. The good news is that it begins with a simple shape. Step by step, we add more nuance until it's complete. By simplifying the process in a gradual sequence, you'll be able to follow along and grasp the subtleties.

Start with a tall, narrow triangle.

Add a curl to the bottom to create the cover of the nostril.

Round off the tip of the nose.

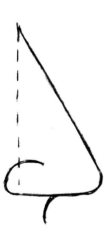

Draw a line extending downward from the bottom of the nose. This will become the upper lip.

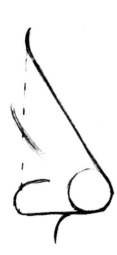

Shade the side of the nose. This will give it the appearance of volume.

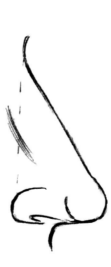

Draw a nostril.

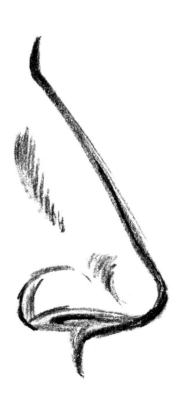

Finished and rendered

Noses—A Selection

Everyone has a differently shaped nose. Some noses turn up at the end while others turn down. Some have a smooth bridge, while others are uneven. Noses can be big or small, round or sharp. Here are a few ideas for you to play with.

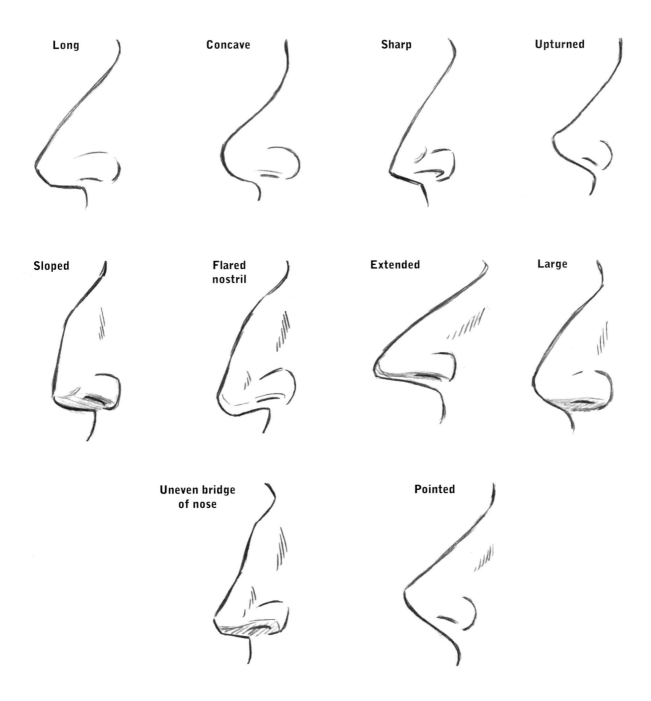

Long

Concave

Sharp

Upturned

Sloped

Flared nostril

Extended

Large

Uneven bridge of nose

Pointed

Adjusting the Features of the Face

I f you want to alter the look of your character, you can do it easily by switching one nose type for another. It makes a difference, which we can see when we substitute different types of noses on the same face.

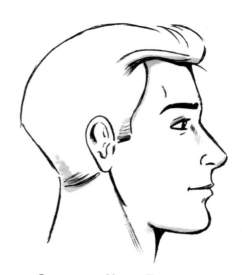

Common Nose Type
This is a well-proportioned nose. Now let's see what he looks like when we switch it for a brand new model.

Nose Types—Male

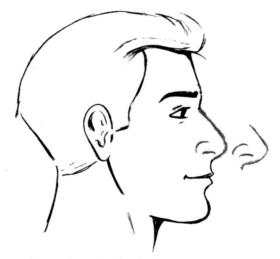

Prominent Nostril

Curved Bridge of the Nose

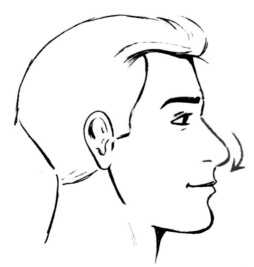

Rounded Tip

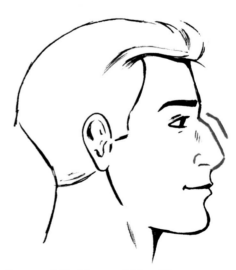

Jagged Bridge of the Nose

Nose Types—Female

The female nose is generally subtler, but no less varied. These are suggestions based on popular types, but you can also invent your own.

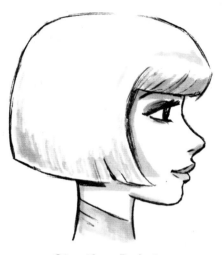

Starting Point
Let's try out a few different noses on this character.

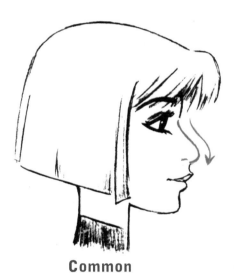

Common

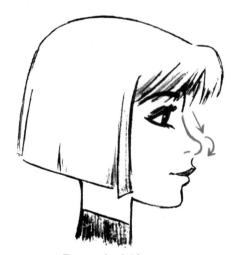

Rounded tip

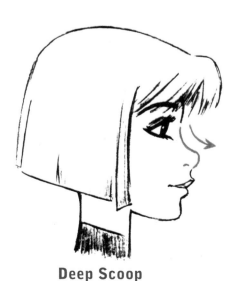

Deep Scoop

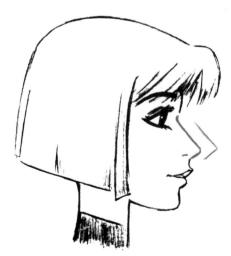

Straight

Understanding Hairstyles

There are general principles for drawing the hair, and they're easy to incorporate into any drawing. The hairstyle often represents a significant portion of the look of the face. To give it life, try to clarify its shape and direction. When you employ these techniques, the haircut looks natural. Let's simplify the concepts and then apply them.

Basic Overview—All the Elements

You don't need to use all of these principles for every drawing. But I'll combine them into a single character so you can see how they affect the total look and how they work together as a unit.

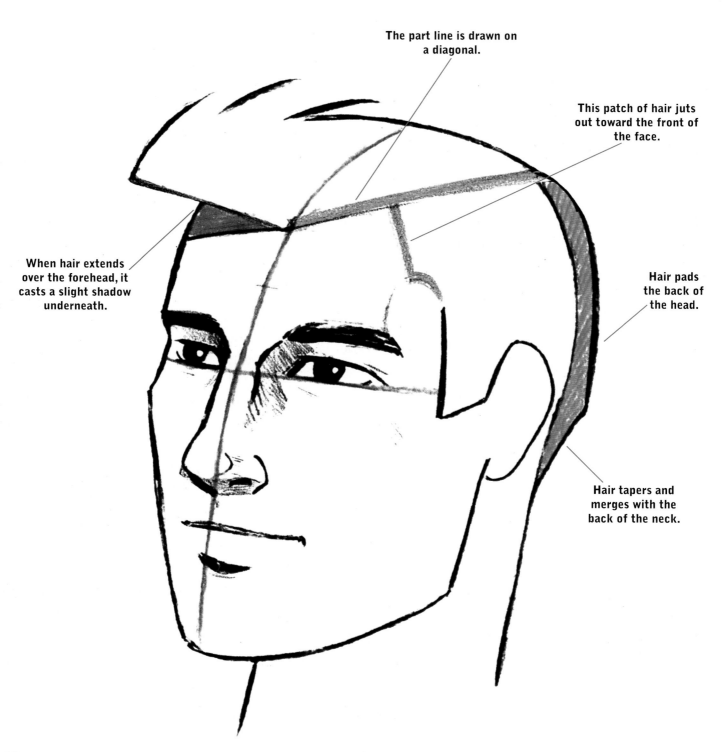

The part line is drawn on a diagonal.

This patch of hair juts out toward the front of the face.

When hair extends over the forehead, it casts a slight shadow underneath.

Hair pads the back of the head.

Hair tapers and merges with the back of the neck.

Male Hairstyles Step by Step

Now we'll apply a few of the basic techniques from the previous page to a popular haircut that we'll draw in an easy progression. When you plot out a logical path for a haircut, the result looks natural and convincing.

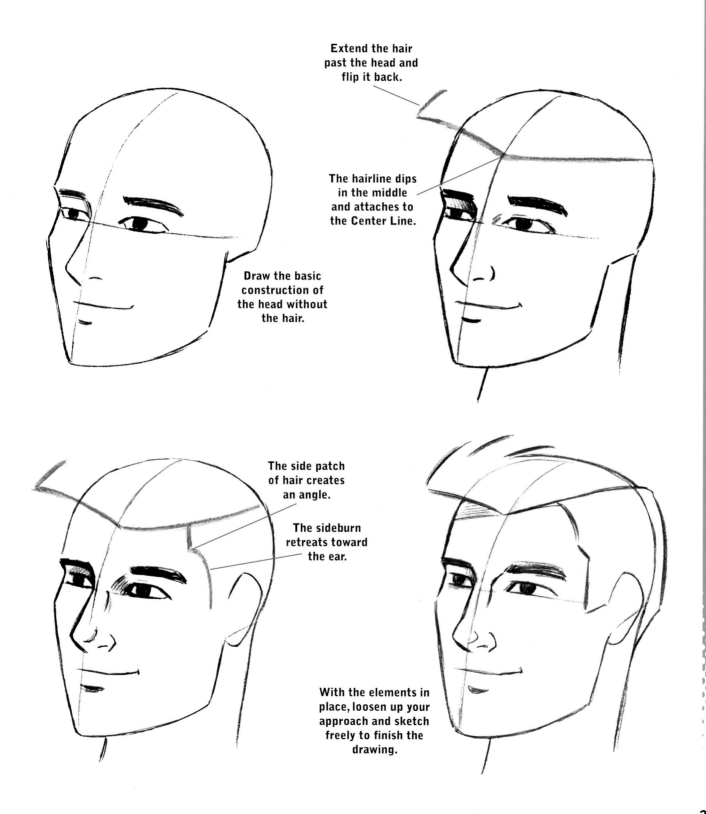

Extend the hair past the head and flip it back.

The hairline dips in the middle and attaches to the Center Line.

Draw the basic construction of the head without the hair.

The side patch of hair creates an angle.

The sideburn retreats toward the ear.

With the elements in place, loosen up your approach and sketch freely to finish the drawing.

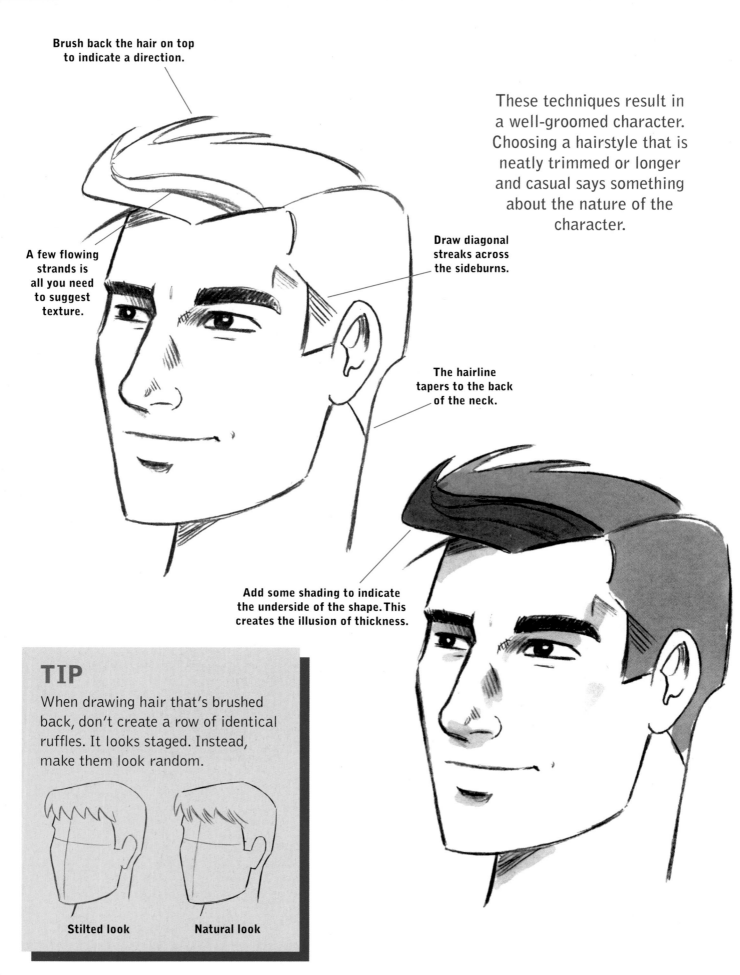

Brush back the hair on top to indicate a direction.

A few flowing strands is all you need to suggest texture.

These techniques result in a well-groomed character. Choosing a hairstyle that is neatly trimmed or longer and casual says something about the nature of the character.

Draw diagonal streaks across the sideburns.

The hairline tapers to the back of the neck.

Add some shading to indicate the underside of the shape. This creates the illusion of thickness.

TIP

When drawing hair that's brushed back, don't create a row of identical ruffles. It looks staged. Instead, make them look random.

Stilted look **Natural look**

Popular Male Hairstyles

Let's try out different haircuts on the same face. It's easier to understand the different techniques if you compare them side by side. When drawing hair, remember the three steps: draw, rinse, repeat.

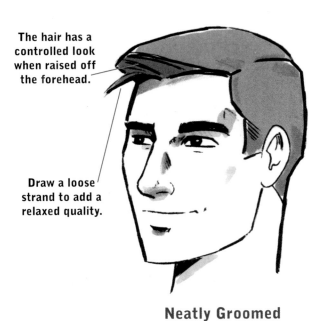

The hair has a controlled look when raised off the forehead.

Draw a loose strand to add a relaxed quality.

Neatly Groomed

Uneven and broken lines

This carefree look features hair that doesn't clump together neatly.

Combed to the Side

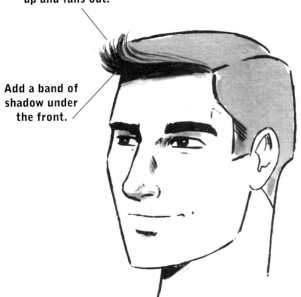

The haircut is 90% controlled until the very end, when the hair flips up and fans out.

Add a band of shadow under the front.

Flipped Up

This is the famous, "I forgot my comb so I ran my fingers through my hair on the way to work" style. Note the streak of light across the hair.

Shag

Female Hairstyles Step by Step

You can get more flow out of a longer hairstyle. But you can get creative with short female haircuts too. They can be cute, stylish, or traditional. Think of women's hairstyles as a complete design, with all the elements coming together to create a single look. Let's try one, step-by-step.

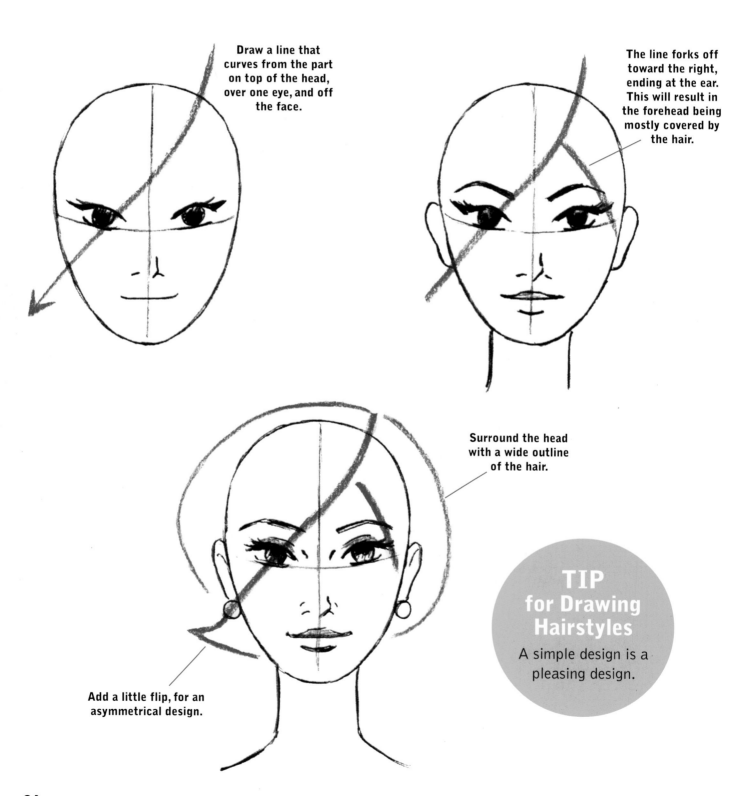

Draw a line that curves from the part on top of the head, over one eye, and off the face.

The line forks off toward the right, ending at the ear. This will result in the forehead being mostly covered by the hair.

Surround the head with a wide outline of the hair.

Add a little flip, for an asymmetrical design.

TIP for Drawing Hairstyles

A simple design is a pleasing design.

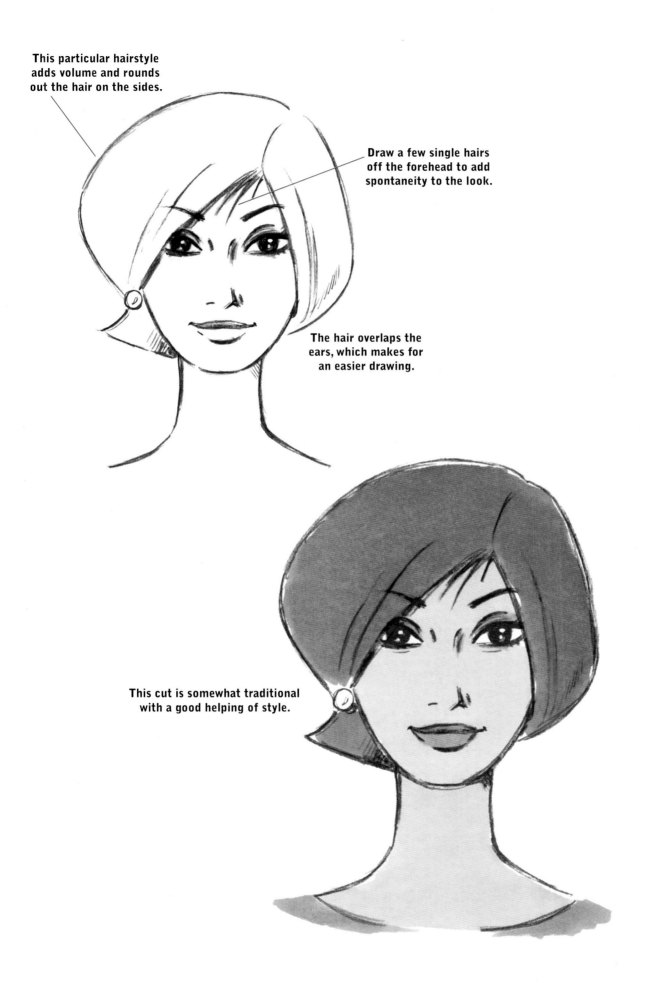

This particular hairstyle adds volume and rounds out the hair on the sides.

Draw a few single hairs off the forehead to add spontaneity to the look.

The hair overlaps the ears, which makes for an easier drawing.

This cut is somewhat traditional with a good helping of style.

More Popular Female Hairstyles

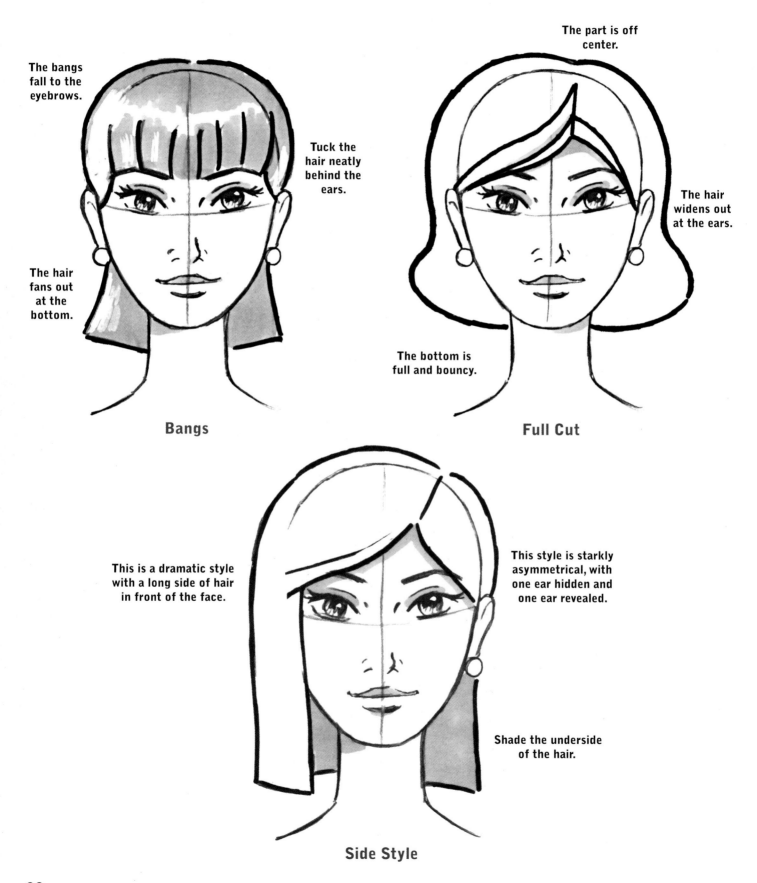

The bangs fall to the eyebrows.

Tuck the hair neatly behind the ears.

The hair fans out at the bottom.

Bangs

The part is off center.

The hair widens out at the ears.

The bottom is full and bouncy.

Full Cut

This is a dramatic style with a long side of hair in front of the face.

This style is starkly asymmetrical, with one ear hidden and one ear revealed.

Shade the underside of the hair.

Side Style

Let it Flow

Carefully crafted hairstyles convey a sense of fashion, but loose hair conveys a sense of energy. The more flow your lines have, the more energy your character has, and the more it will draw the eye of the viewer.

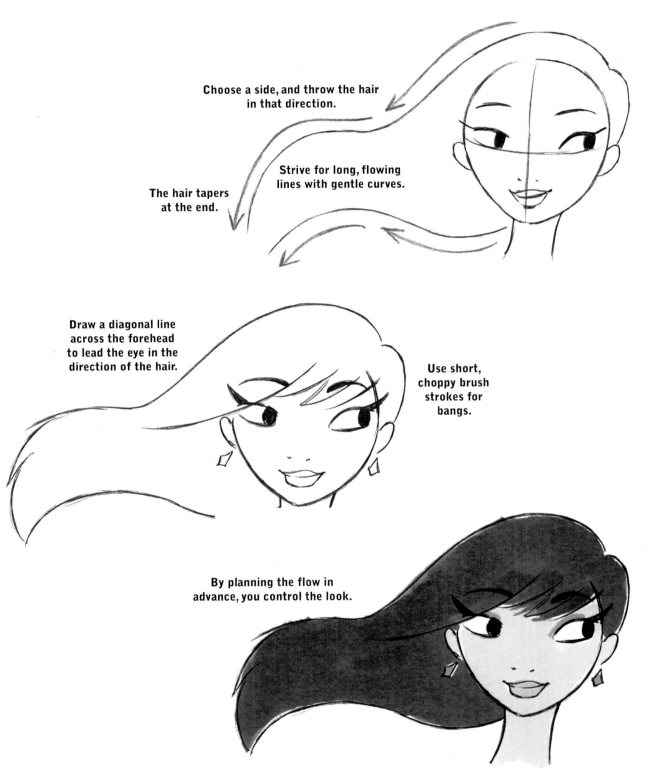

Choose a side, and throw the hair in that direction.

Strive for long, flowing lines with gentle curves.

The hair tapers at the end.

Draw a diagonal line across the forehead to lead the eye in the direction of the hair.

Use short, choppy brush strokes for bangs.

By planning the flow in advance, you control the look.

Get Creative

There are cool and trendy haircuts that break the rules. For example, this hairstyle doesn't flow down; it flows up! But we can still approach it step by step. We'll first define the basic shape. Once that's established, we'll draw the details.

Unique Hairstyles

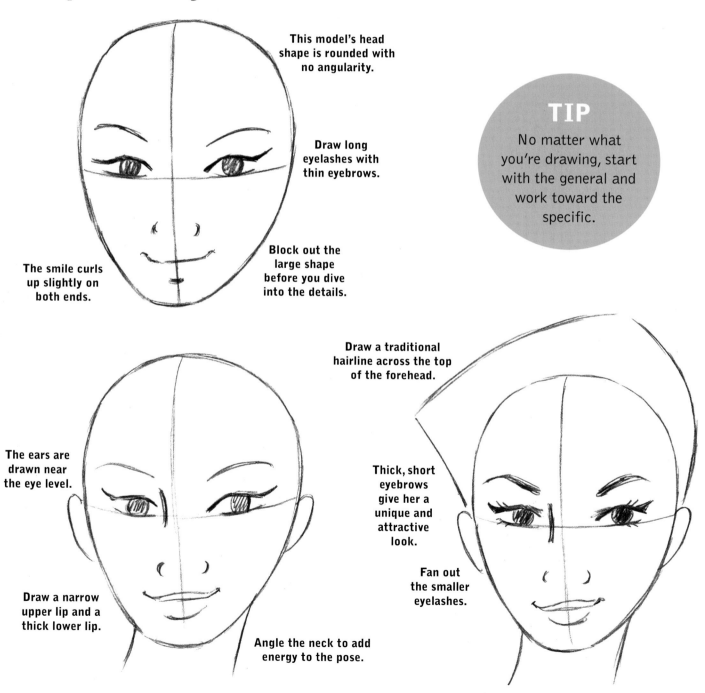

This model's head shape is rounded with no angularity.

Draw long eyelashes with thin eyebrows.

The smile curls up slightly on both ends.

Block out the large shape before you dive into the details.

TIP
No matter what you're drawing, start with the general and work toward the specific.

Draw a traditional hairline across the top of the forehead.

The ears are drawn near the eye level.

Thick, short eyebrows give her a unique and attractive look.

Fan out the smaller eyelashes.

Draw a narrow upper lip and a thick lower lip.

Angle the neck to add energy to the pose.

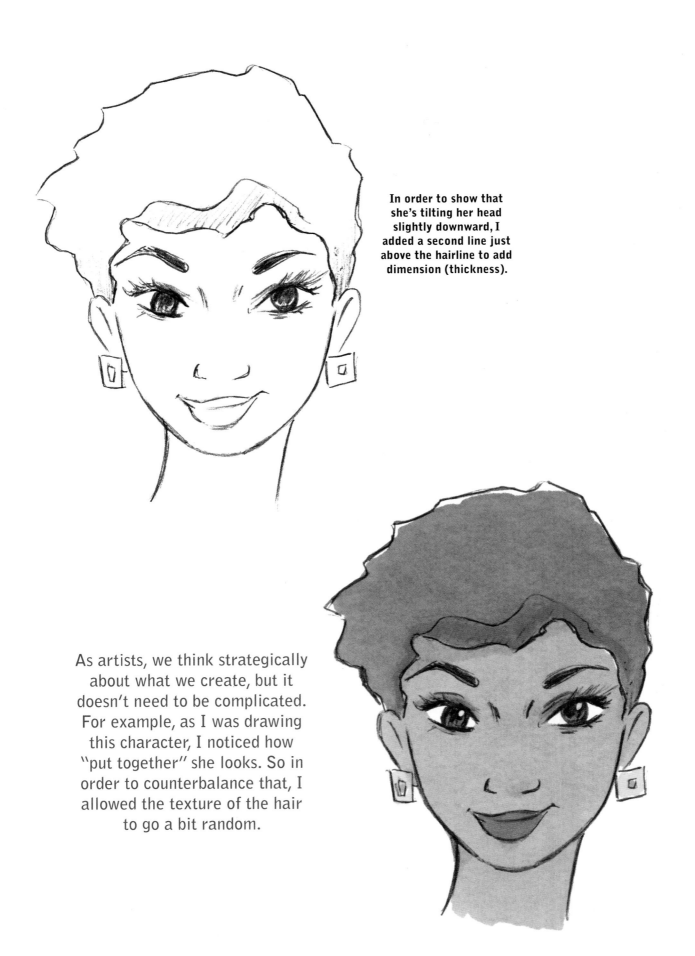

In order to show that she's tilting her head slightly downward, I added a second line just above the hairline to add dimension (thickness).

As artists, we think strategically about what we create, but it doesn't need to be complicated. For example, as I was drawing this character, I noticed how "put together" she looks. So in order to counterbalance that, I allowed the texture of the hair to go a bit random.

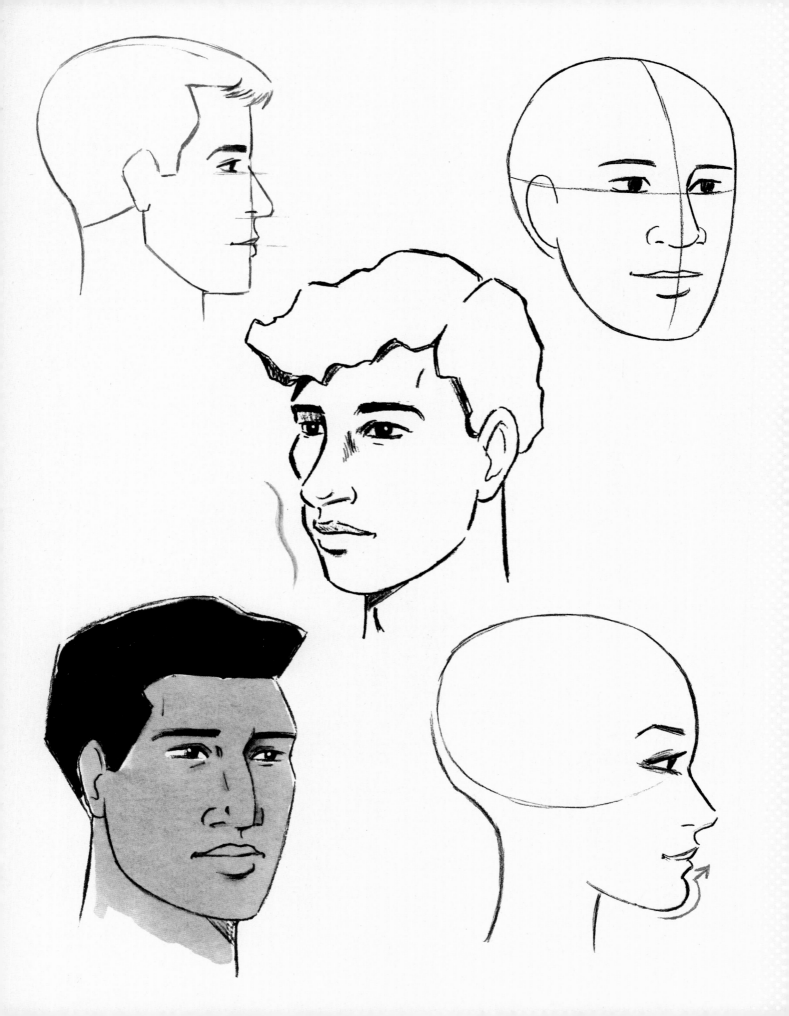

Mastering the Side View

Do you approach the profile by drawing the nose and eyes before completing the rest of the head? Most people work in that order. Let's change it around. Start by drawing the overall shape of the head and proportions, then draw the features. This creates a more convincing head and face.

Side View—Male

Approximate the levels for the features. This isn't set in stone; you can always adjust the features by raising or lowering them a notch.

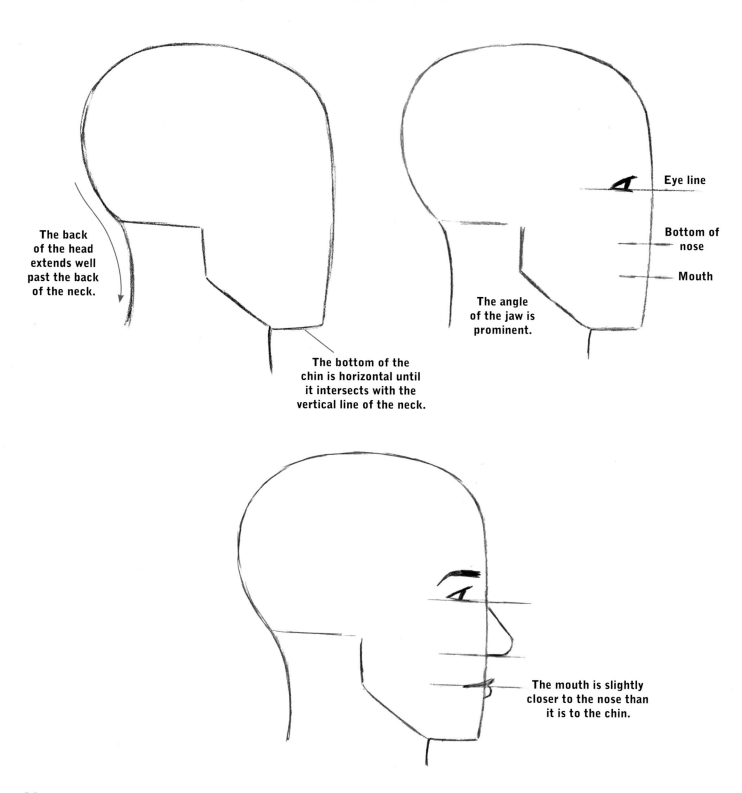

The back of the head extends well past the back of the neck.

The bottom of the chin is horizontal until it intersects with the vertical line of the neck.

Eye line

Bottom of nose

Mouth

The angle of the jaw is prominent.

The mouth is slightly closer to the nose than it is to the chin.

TIP

The interior hairline (in blue), which runs along the forehead, is as important to the look of the drawing as the hair that surrounds the head.

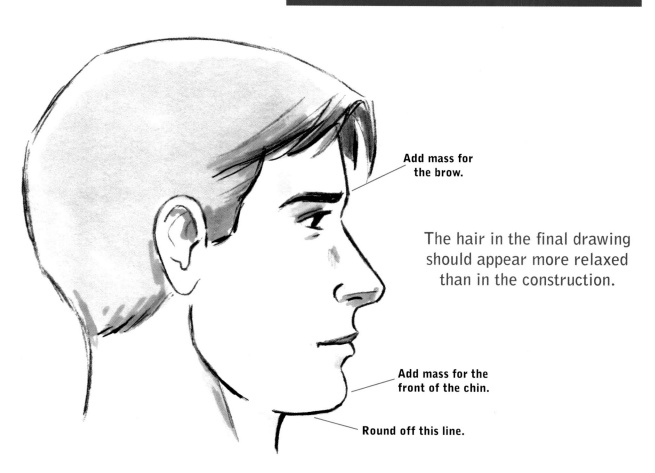

Add mass for the brow.

The hair in the final drawing should appear more relaxed than in the construction.

Add mass for the front of the chin.

Round off this line.

Side View—Female

The differences between the shape of a man's head and a woman's head are subtle—but they're important. The bridge of the nose is drawn with a gentle curve, and the jaw has a greater angle. The forehead is also rounder without the prominent brow, while the neck is narrower.

Mark off the three major measuring points.

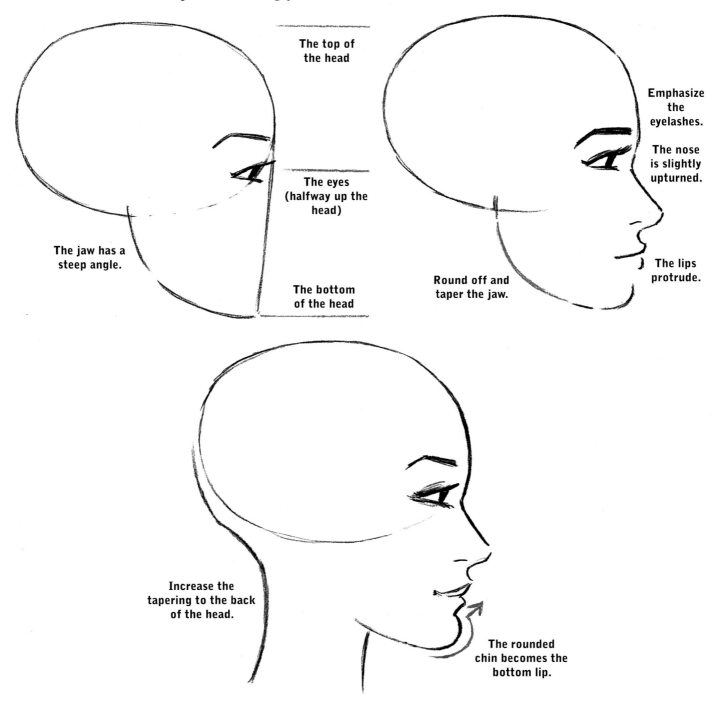

The top of the head

The eyes (halfway up the head)

The jaw has a steep angle.

The bottom of the head

Emphasize the eyelashes.

The nose is slightly upturned.

Round off and taper the jaw.

The lips protrude.

Increase the tapering to the back of the head.

The rounded chin becomes the bottom lip.

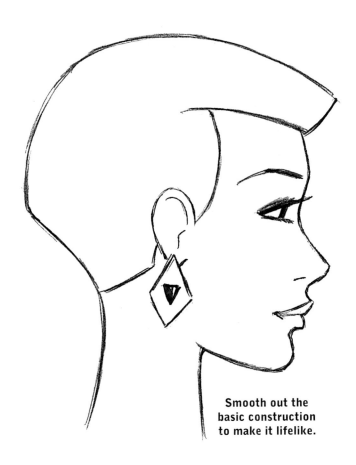

Smooth out the basic construction to make it lifelike.

Tip

For alignment, draw a guideline from the nose, to the lips, to the chin. You don't have to stick rigidly to this, but it's a useful organizing principle.

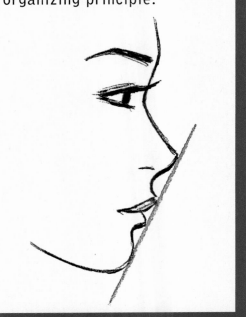

Adding color to dark hair is cool, but somewhat unusual. Taking a slight risk to attain a trendy look is part of fashion illustration.

Three-Quarter Angle—Male

There's a lot happening in a 3/4 view, because the angle creates unevenness: The left side of the face is three-fourths of the drawing. To keep the features in alignment, we're going to rely on the Center Line.

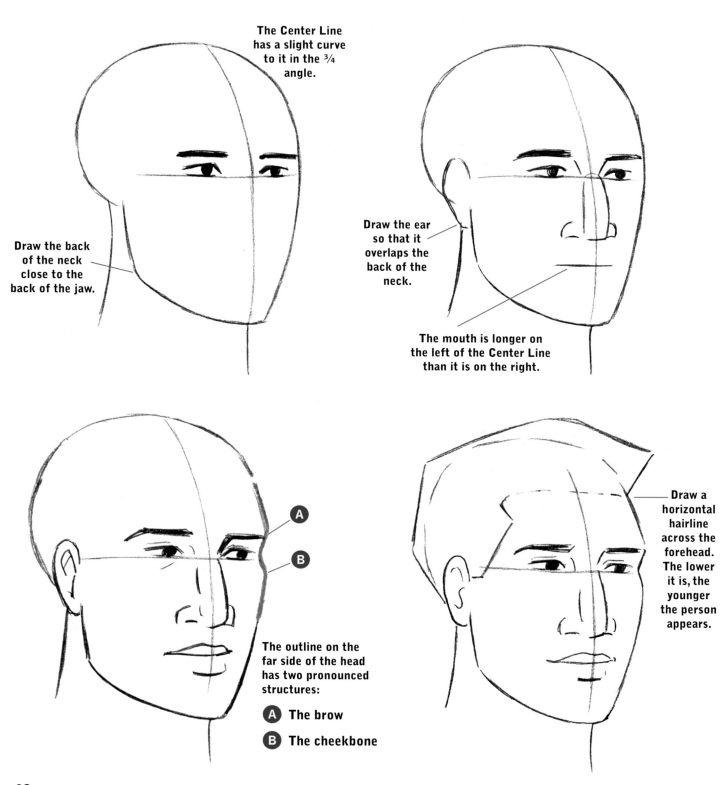

The **Center Line** has a slight curve to it in the ¾ angle.

Draw the back of the neck close to the back of the jaw.

Draw the ear so that it overlaps the back of the neck.

The mouth is longer on the left of the Center Line than it is on the right.

A

B

The outline on the far side of the head has two pronounced structures:

A The brow

B The cheekbone

Draw a horizontal hairline across the forehead. The lower it is, the younger the person appears.

Three-Quarter Angle Detail

The indentation of the upper lip is bisected by the Center Line.

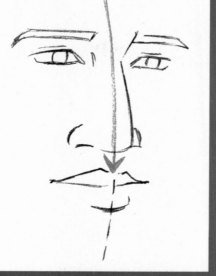

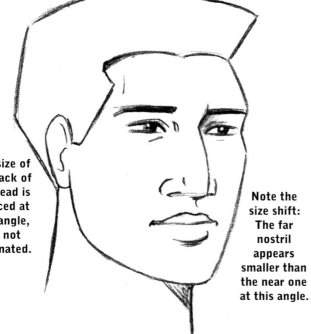

The size of the back of the head is reduced at this angle, but not eliminated.

Note the size shift: The far nostril appears smaller than the near one at this angle.

Jet black hair creates a striking look, so there's no need to add highlights.

49

How to Adjust the Head Shape

To create a convincing head in the 3/4 view, you'll want to emphasize four areas: the brow, cheekbone, chin, and jawbone. Let's lock in this principle, which was hinted at on the previous page.

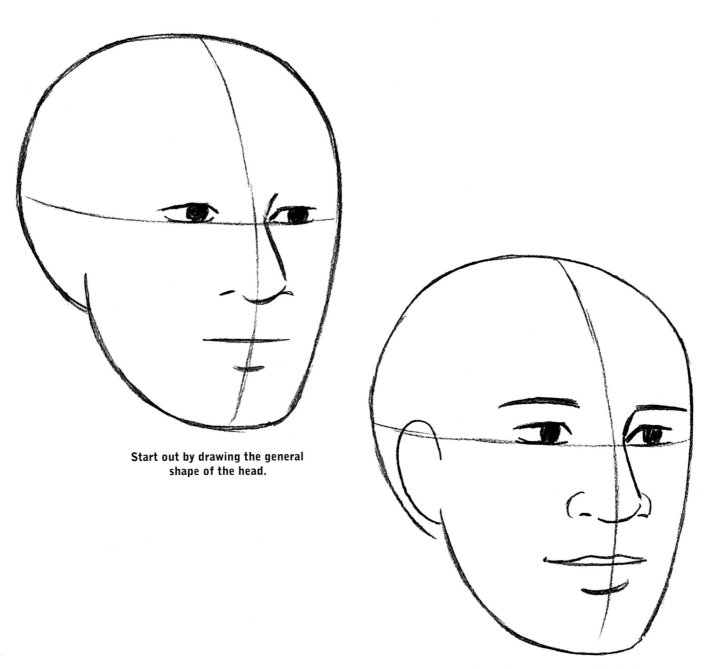

Start out by drawing the general shape of the head.

Draw the placement of the features. Keep it basic at this stage. (We'll add the details later.)

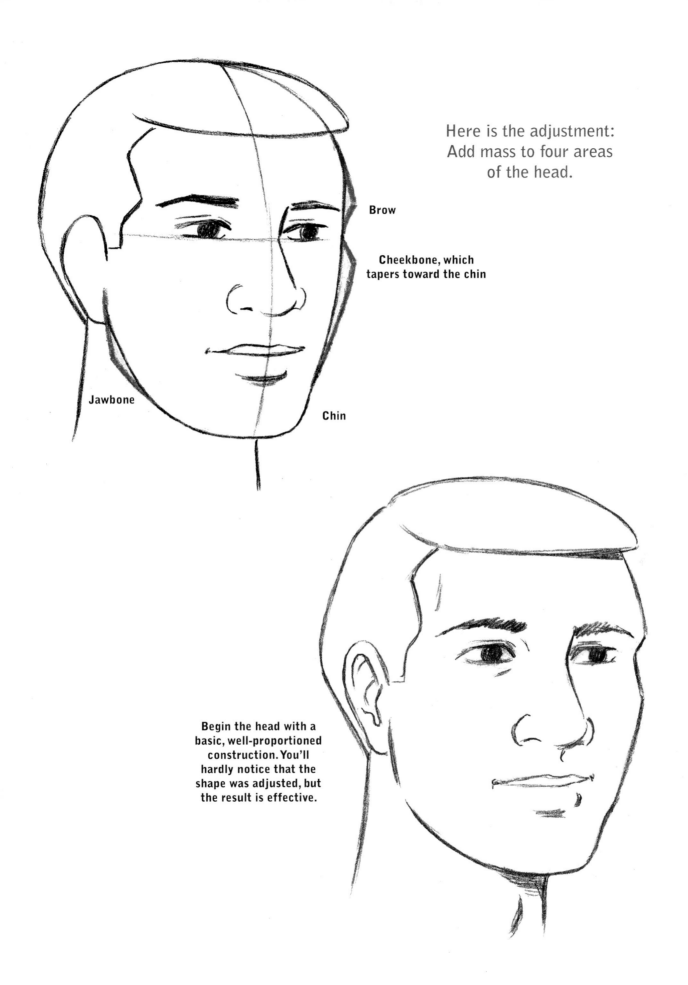

Here is the adjustment:
Add mass to four areas
of the head.

Brow

**Cheekbone, which
tapers toward the chin**

Jawbone

Chin

Begin the head with a
basic, well-proportioned
construction. You'll
hardly notice that the
shape was adjusted, but
the result is effective.

The Mouth Area

Another important detail for drawing the head in a 3/4 angle is the contour around the mouth. A ring of tissue surrounds the mouth that causes it to curve outward. It's easy to draw. Let's take a look at how it's done.

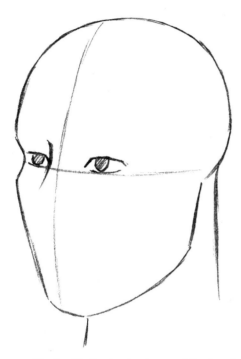

Start with the basic shape of the head.

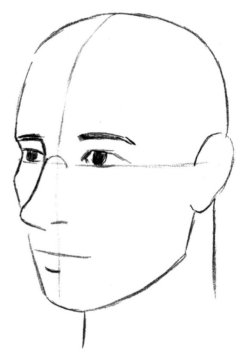

Draw the basic features, going for placement only.

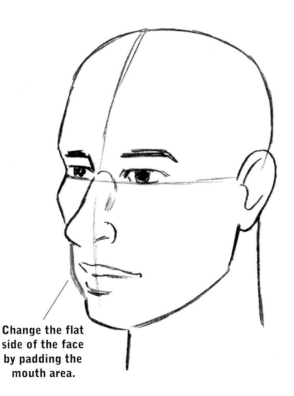

Change the flat side of the face by padding the mouth area.

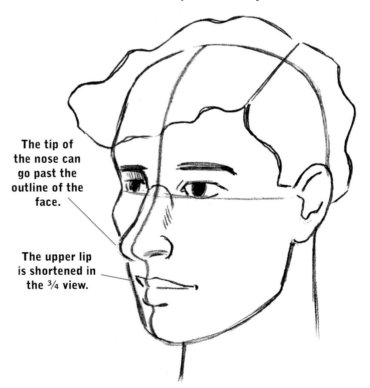

The tip of the nose can go past the outline of the face.

The upper lip is shortened in the 3/4 view.

TIP

Adding details, when based on an accurate understanding of the form, gives your drawings an air of proficiency.

By curving the outline of the face around the mouth, you create a natural look, because a contoured line is more lifelike than a straight line.

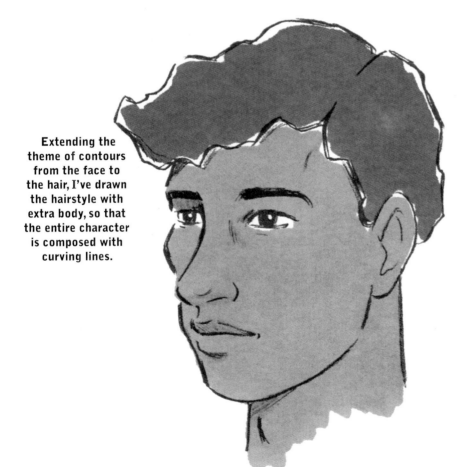

Extending the theme of contours from the face to the hair, I've drawn the hairstyle with extra body, so that the entire character is composed with curving lines.

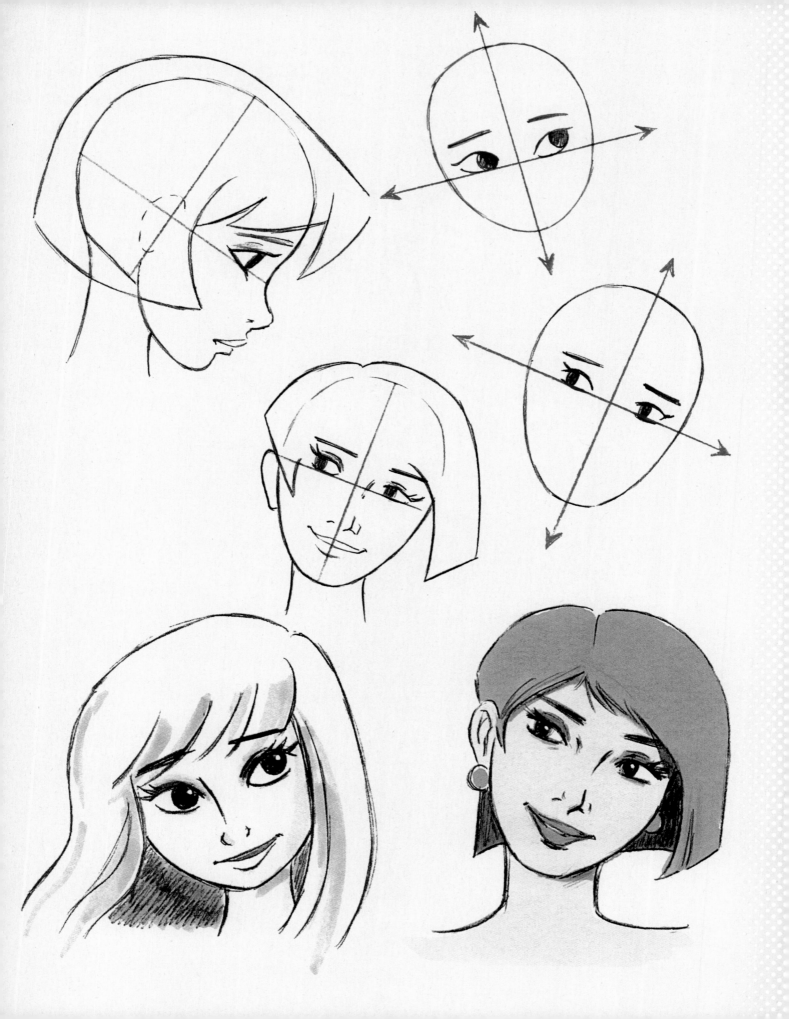

Tilting the Head

Because we're so accustomed, as artists, to think about the body in motion, we don't often stop to consider that the head tilts as well. With a small movement of the head, a look or expression can be enhanced. And there's also a benefit to drawing things you're familiar with in unfamiliar positions. It prompts you to call on your analytical skills.

What Is a Tilt?

Drawing the head with a tilt is a useful technique. But what exactly is a tilt? Is it different from an angle? Yes. Angles are front, side, and ¾. Tilts are up and down or left and right. And they can be combined with angles.

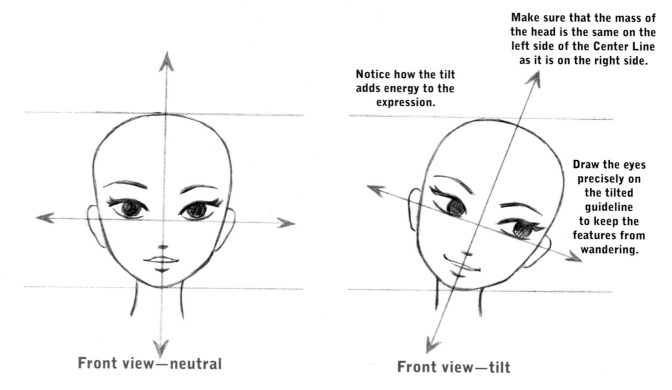

Notice how the tilt adds energy to the expression.

Make sure that the mass of the head is the same on the left side of the Center Line as it is on the right side.

Draw the eyes precisely on the tilted guideline to keep the features from wandering.

Front view—neutral

Front view—tilt

Tilt to the Left

Let's take this step by step. The first step, where you draw the shape of the head and the tilted guidelines, is the most important part of this drawing.

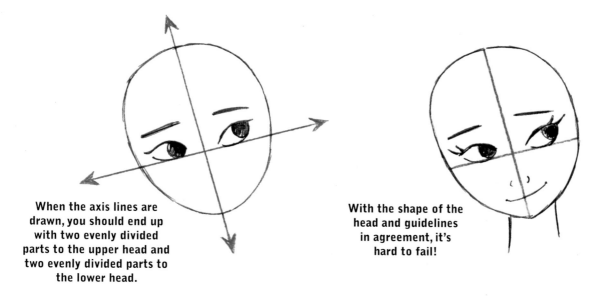

When the axis lines are drawn, you should end up with two evenly divided parts to the upper head and two evenly divided parts to the lower head.

With the shape of the head and guidelines in agreement, it's hard to fail!

56

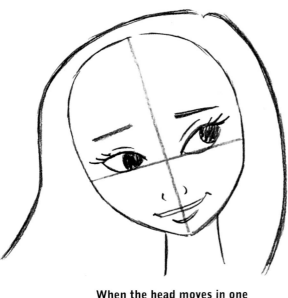

When the head moves in one direction, the hair moves in the opposite direction.

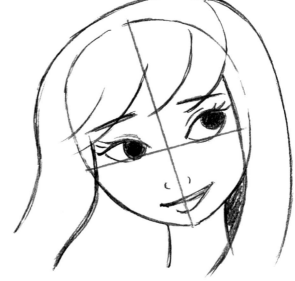

The hair doesn't need to move in lock step with the tilt of the head. This frees you up to draw it with a looser line.

TIP

Adding a few gray highlights helps to soften a character's look.

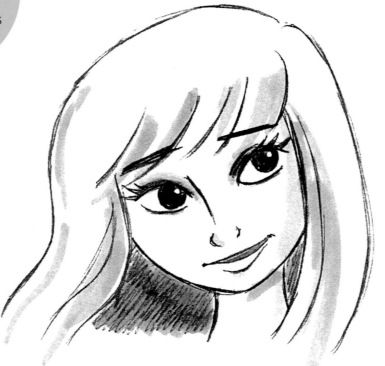

I like to add gray highlights or some other muted color. It creates an image that's not as stark as black and white.

57

Tilt Down

The profile presents an easier way to draw a tilt than the front view. Can you guess why? It's because you don't have to align both eyes. Along with the downward tilt of the eye, the tilt of the nose is also important.

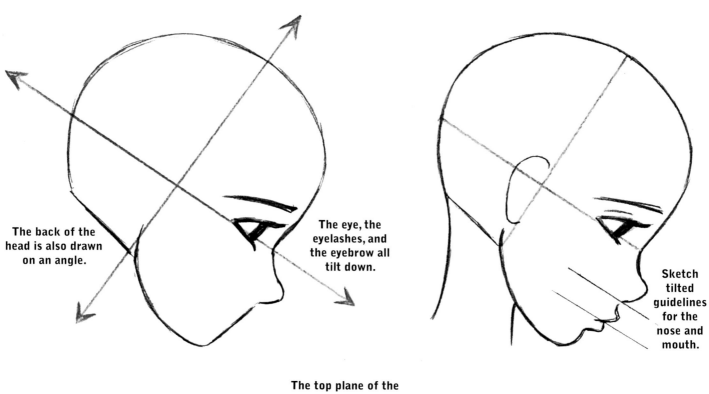

The back of the head is also drawn on an angle.

The eye, the eyelashes, and the eyebrow all tilt down.

Sketch tilted guidelines for the nose and mouth.

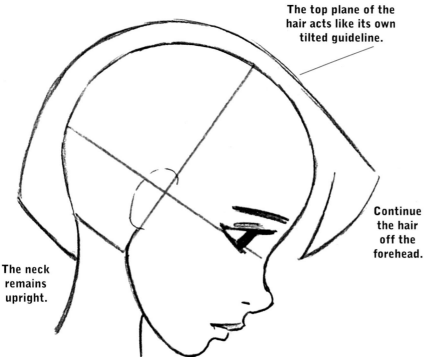

The top plane of the hair acts like its own tilted guideline.

The neck remains upright.

Continue the hair off the forehead.

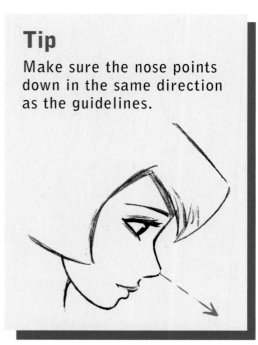

Tip

Make sure the nose points down in the same direction as the guidelines.

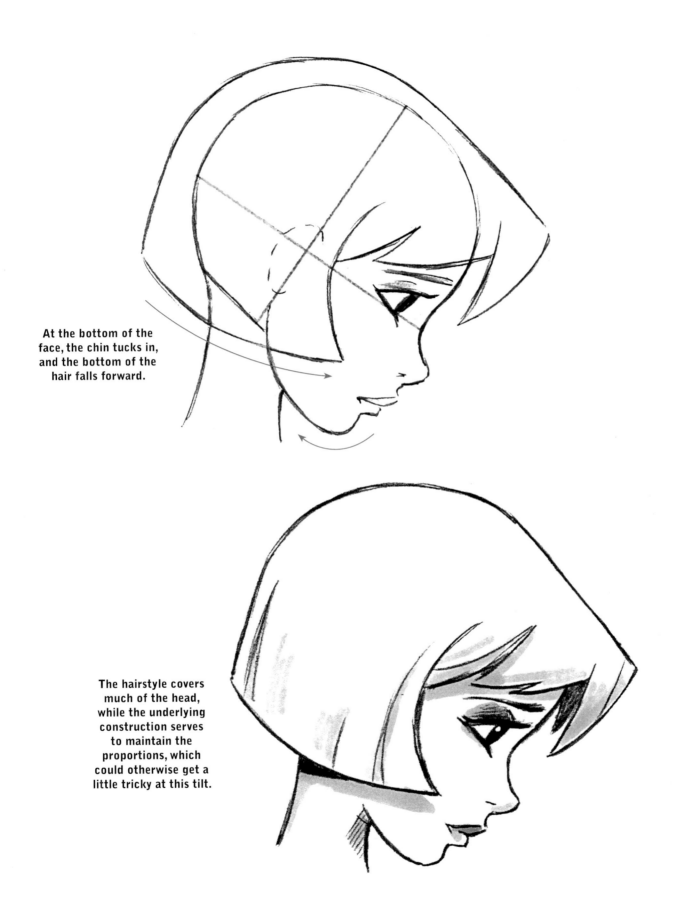

At the bottom of the face, the chin tucks in, and the bottom of the hair falls forward.

The hairstyle covers much of the head, while the underlying construction serves to maintain the proportions, which could otherwise get a little tricky at this tilt.

DRAWING THE BODY

The human body is an amazing machine. It moves as a unit, yet it's assembled from sections. It's our job as artists to merge these sections together in a way that looks smooth, natural, and unplanned. In other words, we want to fool the viewer into thinking we didn't use any effort! As we did in the first half of this book, we'll work from general shapes to specific ones. Along the way, I'll give you tips and techniques to help you grasp the concepts.

The Upper Body—Male

We'll begin with the torso, which is the foundation of the body. We can reduce it to a few basic building blocks which will make the concepts easy to grasp.

The building blocks of the torso are:

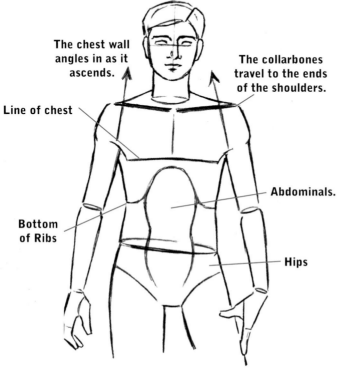

The chest wall angles in as it ascends.

Line of chest

Bottom of Ribs

The collarbones travel to the ends of the shoulders.

Abdominals.

Hips

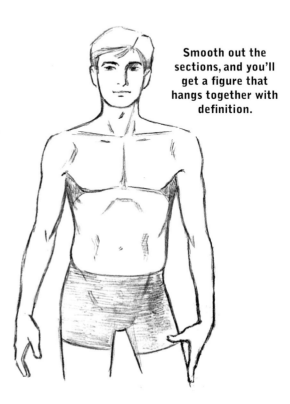

Smooth out the sections, and you'll get a figure that hangs together with definition.

The Basics of the Torso

Let's further define the torso while maintaining our basic approach. Combine the ribcage with the stomach and collarbone to create a structure that will serve as the basis for drawing the upper body.

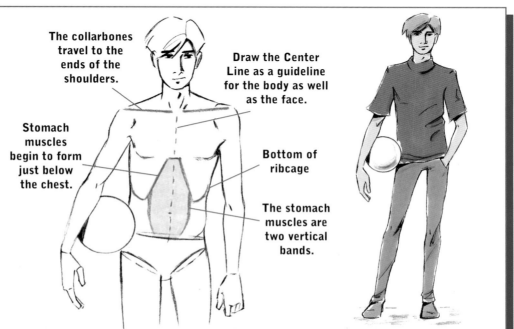

The collarbones travel to the ends of the shoulders.

Stomach muscles begin to form just below the chest.

Draw the Center Line as a guideline for the body as well as the face.

Bottom of ribcage

The stomach muscles are two vertical bands.

The Upper Body—Female

The average female figure has a few differences in the proportions of the torso and, most especially, the hips.

Upper Body—Female

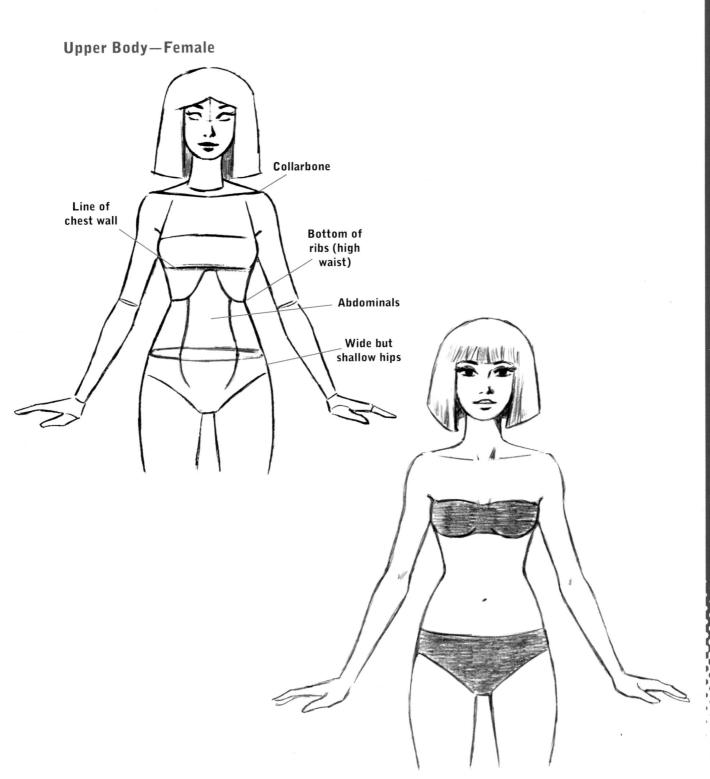

Collarbone

Line of chest wall

Bottom of ribs (high waist)

Abdominals

Wide but shallow hips

The Torso—3/4 Angle

Just like any object turned to the left or right, the far side will appear narrower. The trick for drawing the torso at this angle is to draw the far side of the abdominal wall narrower than the near side.

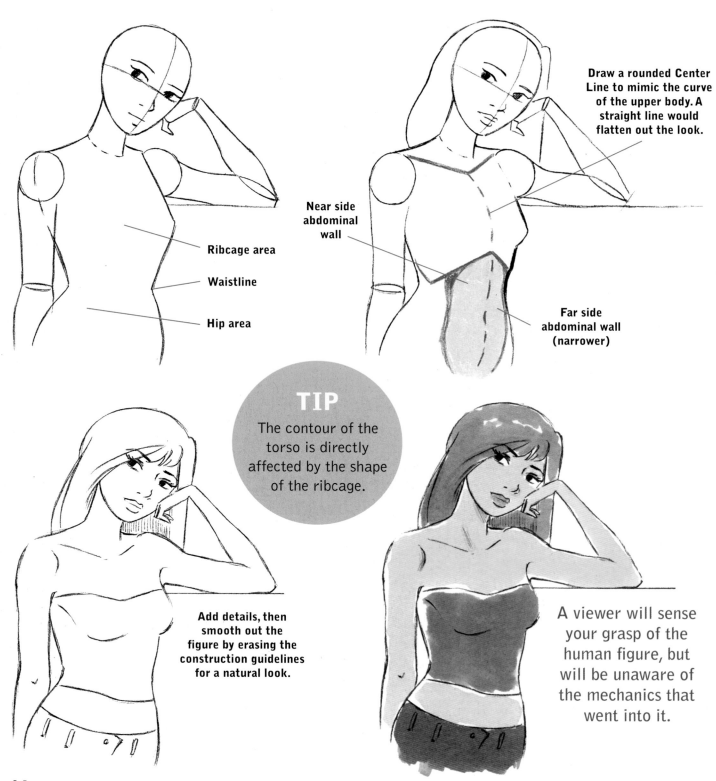

Draw a rounded Center Line to mimic the curve of the upper body. A straight line would flatten out the look.

Ribcage area

Waistline

Hip area

Near side abdominal wall

Far side abdominal wall (narrower)

TIP
The contour of the torso is directly affected by the shape of the ribcage.

Add details, then smooth out the figure by erasing the construction guidelines for a natural look.

A viewer will sense your grasp of the human figure, but will be unaware of the mechanics that went into it.

Side View—Upper Body

In the side view, the upper body can be drawn as a single shape. For men, the shape is slightly top heavy, and for women, it's the opposite. As with all guidelines, you can adjust them to create individuals.

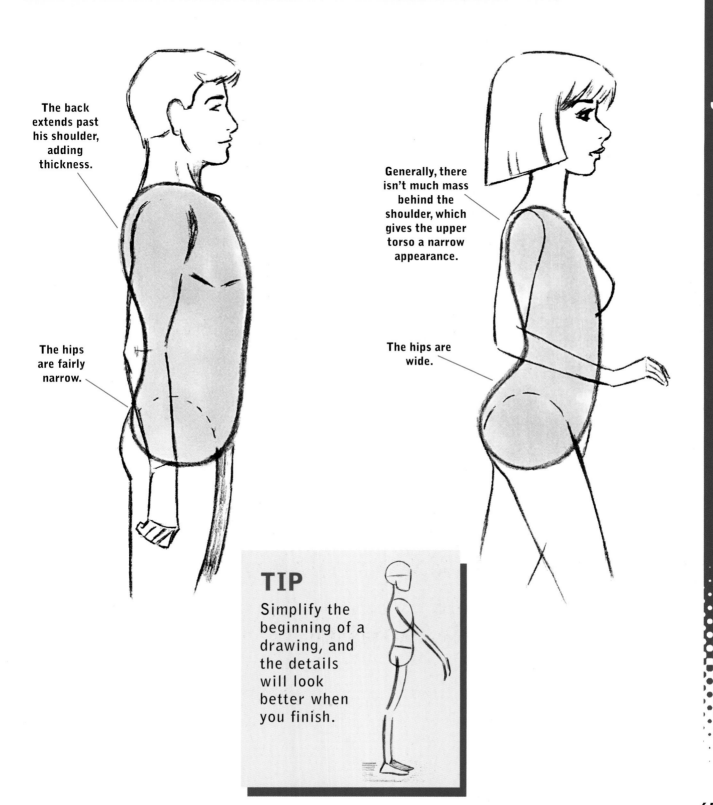

The back extends past his shoulder, adding thickness.

The hips are fairly narrow.

Generally, there isn't much mass behind the shoulder, which gives the upper torso a narrow appearance.

The hips are wide.

TIP

Simplify the beginning of a drawing, and the details will look better when you finish.

Side View—Step by Step

The back is made up of various sections. Each section takes a different angle. Knowing when to shift the angle, and to what degree, will allow you to create a fluid pose.

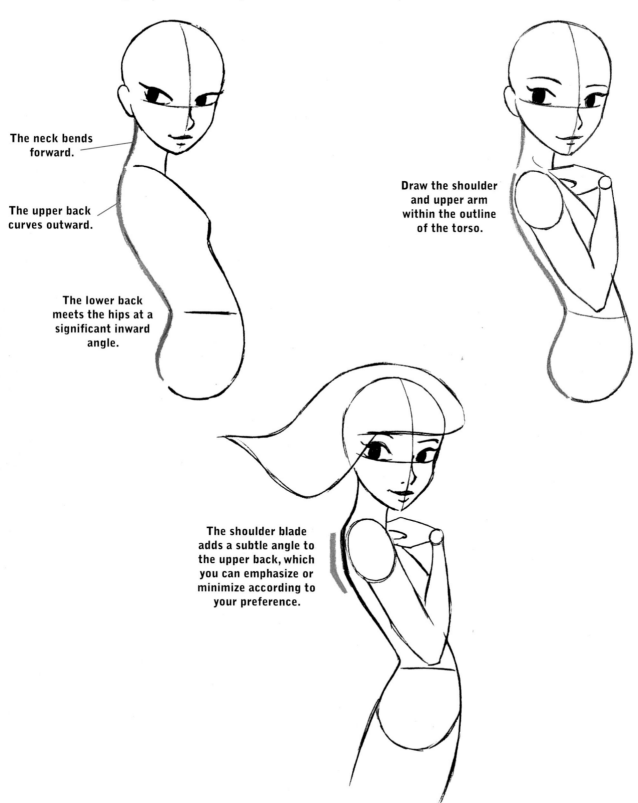

The neck bends forward.

The upper back curves outward.

The lower back meets the hips at a significant inward angle.

Draw the shoulder and upper arm within the outline of the torso.

The shoulder blade adds a subtle angle to the upper back, which you can emphasize or minimize according to your preference.

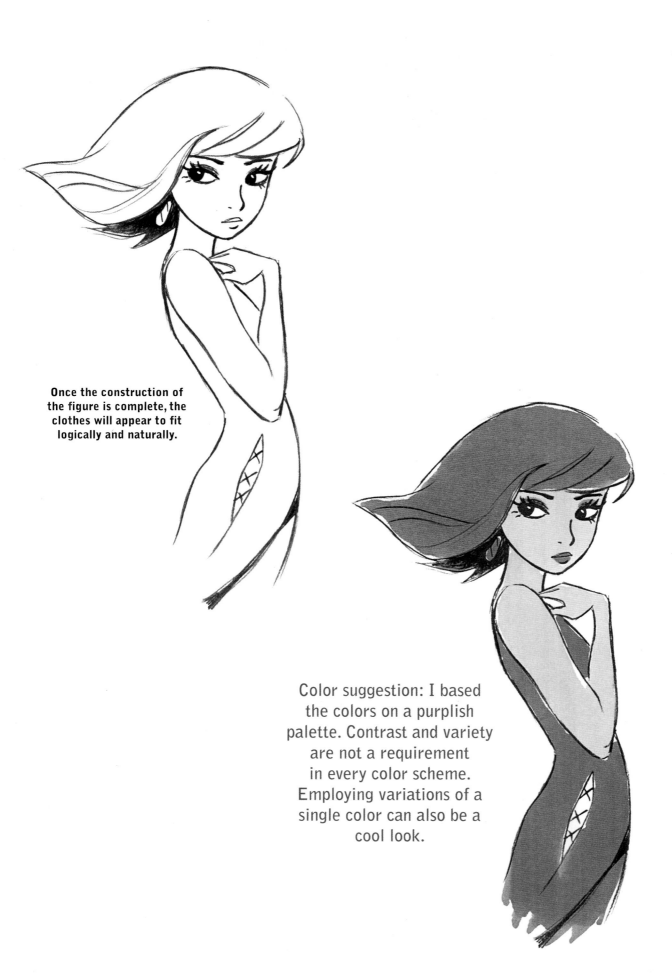

Once the construction of the figure is complete, the clothes will appear to fit logically and naturally.

Color suggestion: I based the colors on a purplish palette. Contrast and variety are not a requirement in every color scheme. Employing variations of a single color can also be a cool look.

Practice Poses—Step by Step

Let's take what we've learned so far about drawing the upper body and apply it to some appealing poses that work well in drawings that focus on the head and torso. Along the way, I'll introduce some new tips and techniques that I think you'll like. So, sharpen your pencil, pull up a chair, and let's begin.

Casual Standing Pose

When a person stands frontward, it tends to create a symmetrical pose. Sometimes that's good, but it can also work against you in that it creates a well-balanced but neutral pose. If that occurs, use the arms to break up the symmetry. Often, a simple solution like this is enough to do the trick.

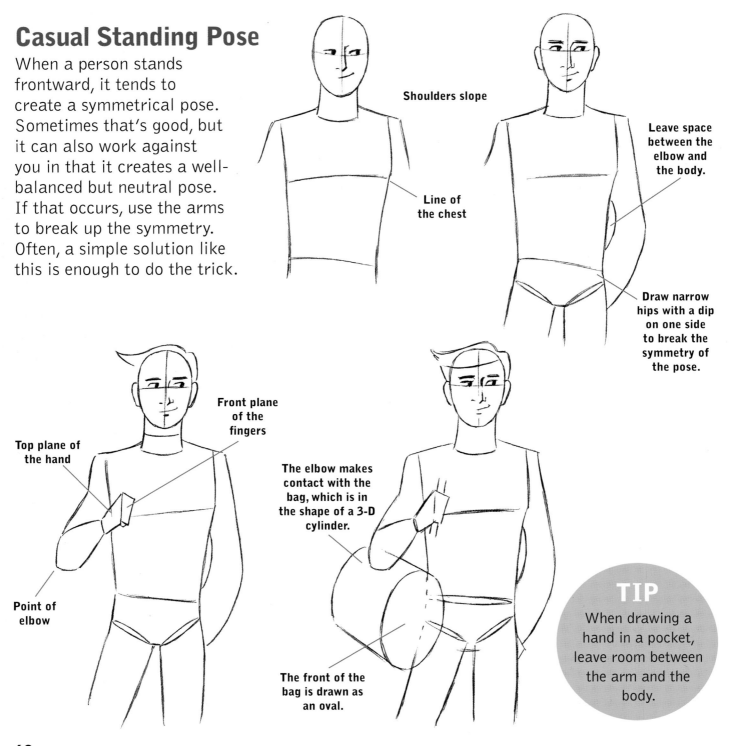

Shoulders slope

Line of the chest

Leave space between the elbow and the body.

Draw narrow hips with a dip on one side to break the symmetry of the pose.

Front plane of the fingers

Top plane of the hand

Point of elbow

The elbow makes contact with the bag, which is in the shape of a 3-D cylinder.

The front of the bag is drawn as an oval.

TIP
When drawing a hand in a pocket, leave room between the arm and the body.

68

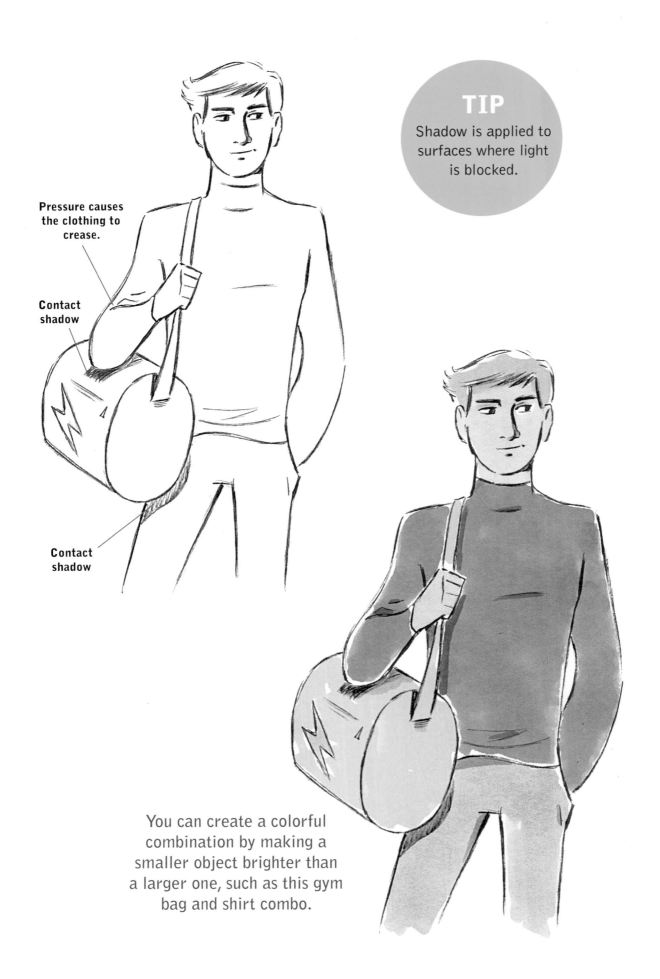

TIP
Shadow is applied to surfaces where light is blocked.

Pressure causes the clothing to crease.

Contact shadow

Contact shadow

You can create a colorful combination by making a smaller object brighter than a larger one, such as this gym bag and shirt combo.

Dynamic Standing Pose

At first, this character appears to be standing straight. But upon closer inspection, we see that the spine bends to the left, which adds life to the pose. The arm and leg positions demonstrate some overlapping.

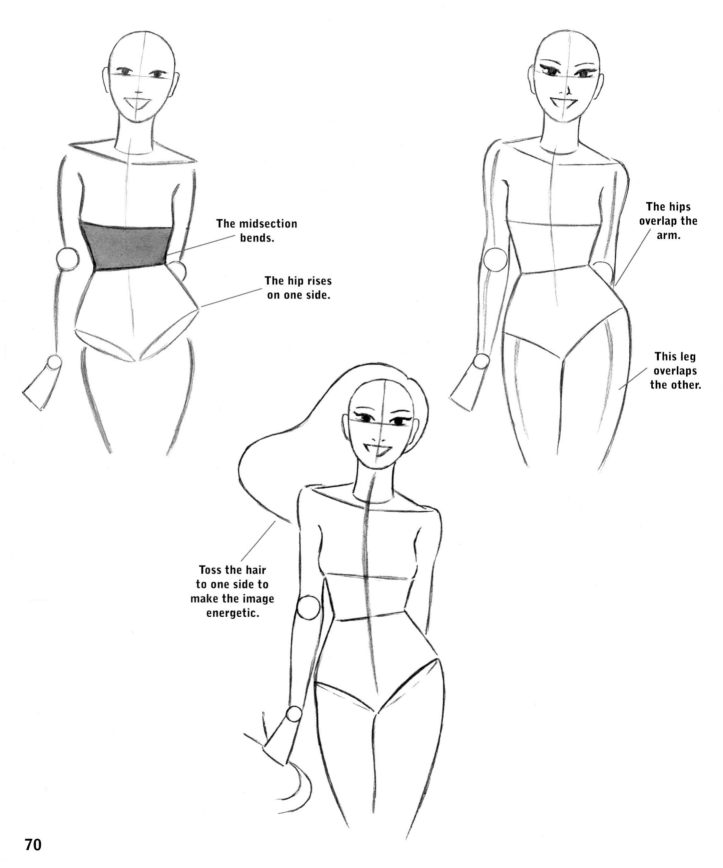

The midsection bends.

The hip rises on one side.

The hips overlap the arm.

This leg overlaps the other.

Toss the hair to one side to make the image energetic.

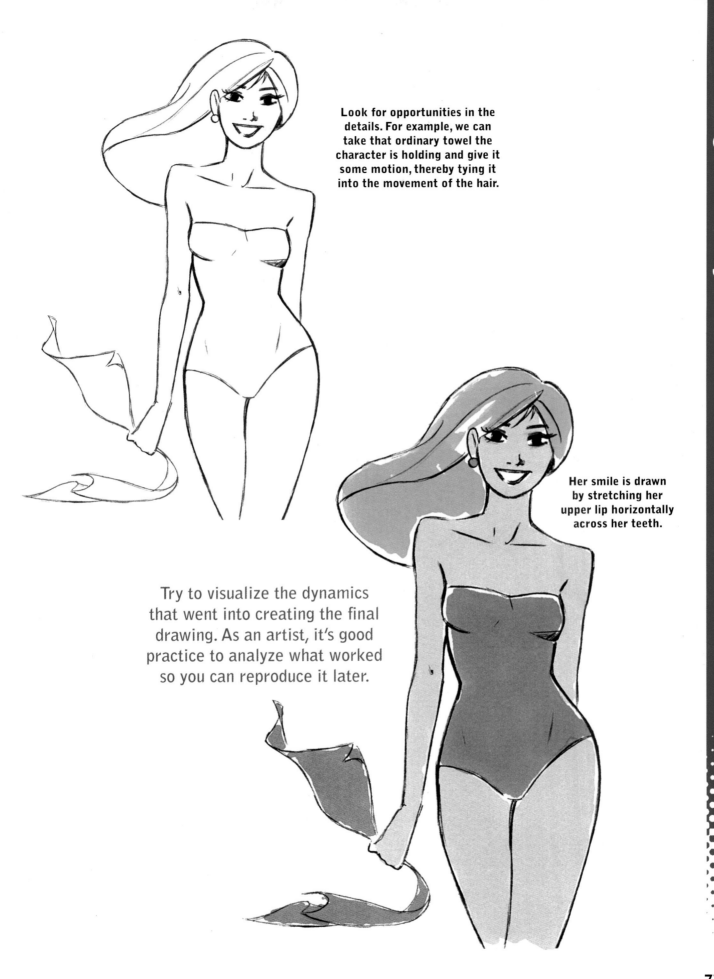

Look for opportunities in the details. For example, we can take that ordinary towel the character is holding and give it some motion, thereby tying it into the movement of the hair.

Try to visualize the dynamics that went into creating the final drawing. As an artist, it's good practice to analyze what worked so you can reproduce it later.

Her smile is drawn by stretching her upper lip horizontally across her teeth.

71

Leaning Back

This standing pose creates a T shape with the horizontally positioned arms and vertical body. Let's take it step-by-step.

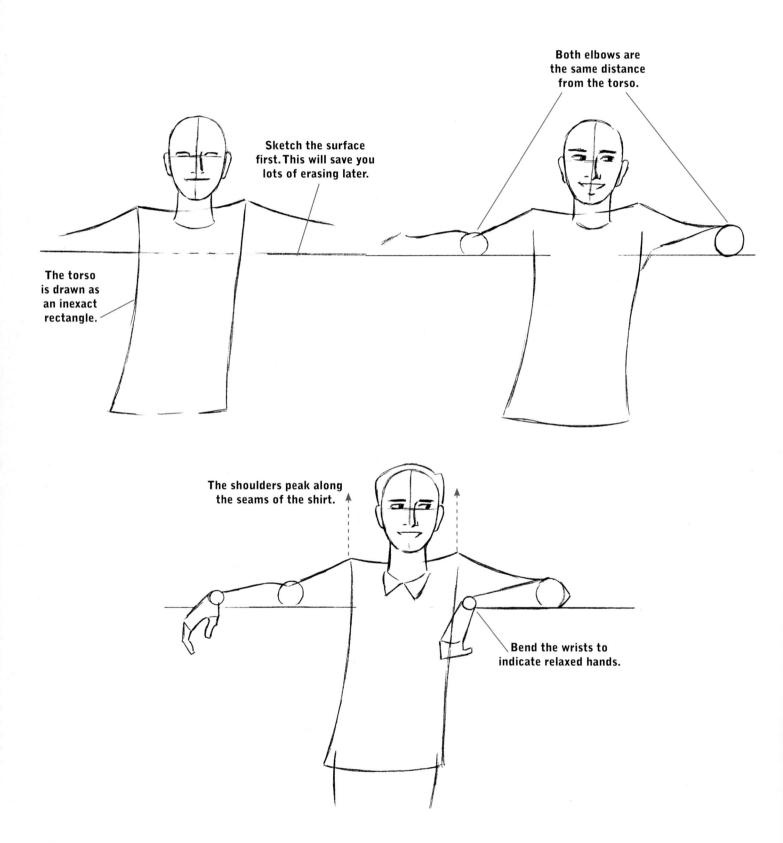

Sketch the surface first. This will save you lots of erasing later.

The torso is drawn as an inexact rectangle.

Both elbows are the same distance from the torso.

The shoulders peak along the seams of the shirt.

Bend the wrists to indicate relaxed hands.

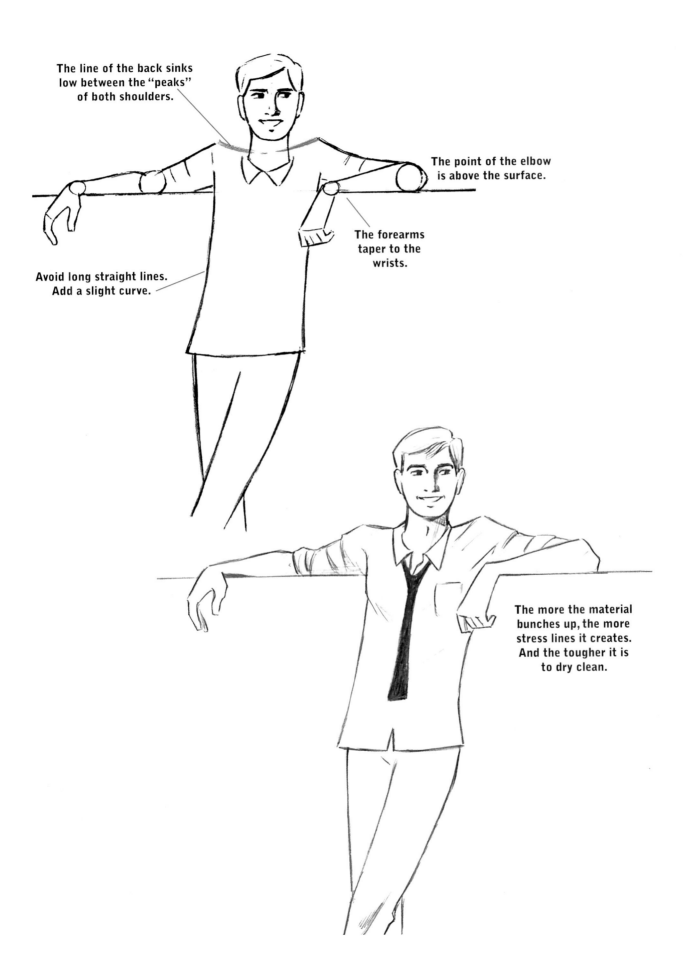

The line of the back sinks low between the "peaks" of both shoulders.

The point of the elbow is above the surface.

The forearms taper to the wrists.

Avoid long straight lines. Add a slight curve.

The more the material bunches up, the more stress lines it creates. And the tougher it is to dry clean.

Standing at an Angle

What happens when you turn the figure from a front view to the left or the right? The dynamics change, but we can simplify them by focusing on the sections of the body. Remember at the beginning of this chapter when we learned to draw the body in sections? Now is a good time to use that technique. It will force us to build the figure logically.

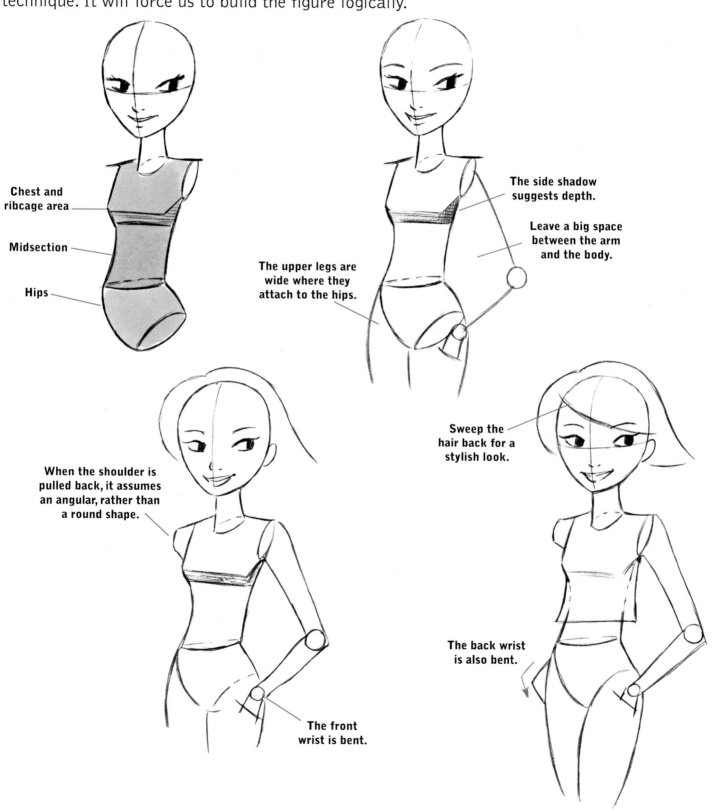

Chest and ribcage area

Midsection

Hips

The side shadow suggests depth.

Leave a big space between the arm and the body.

The upper legs are wide where they attach to the hips.

When the shoulder is pulled back, it assumes an angular, rather than a round shape.

The front wrist is bent.

Sweep the hair back for a stylish look.

The back wrist is also bent.

Create an illustrated style by exaggerating the size of the head relative to the body.

Let the top hang loose, and add a slight shadow under it.

Use long, curved lines for the outline of the legs.

The Key: In the final drawing, the various sections of the torso are still apparent, but smoothly attached to one another.

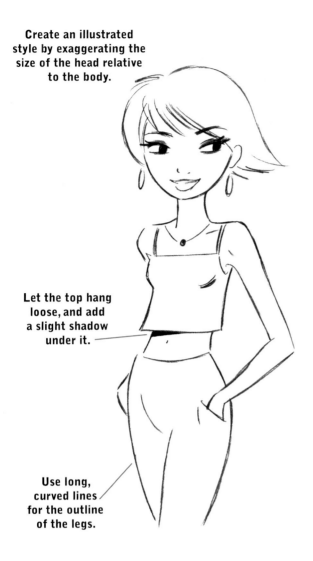

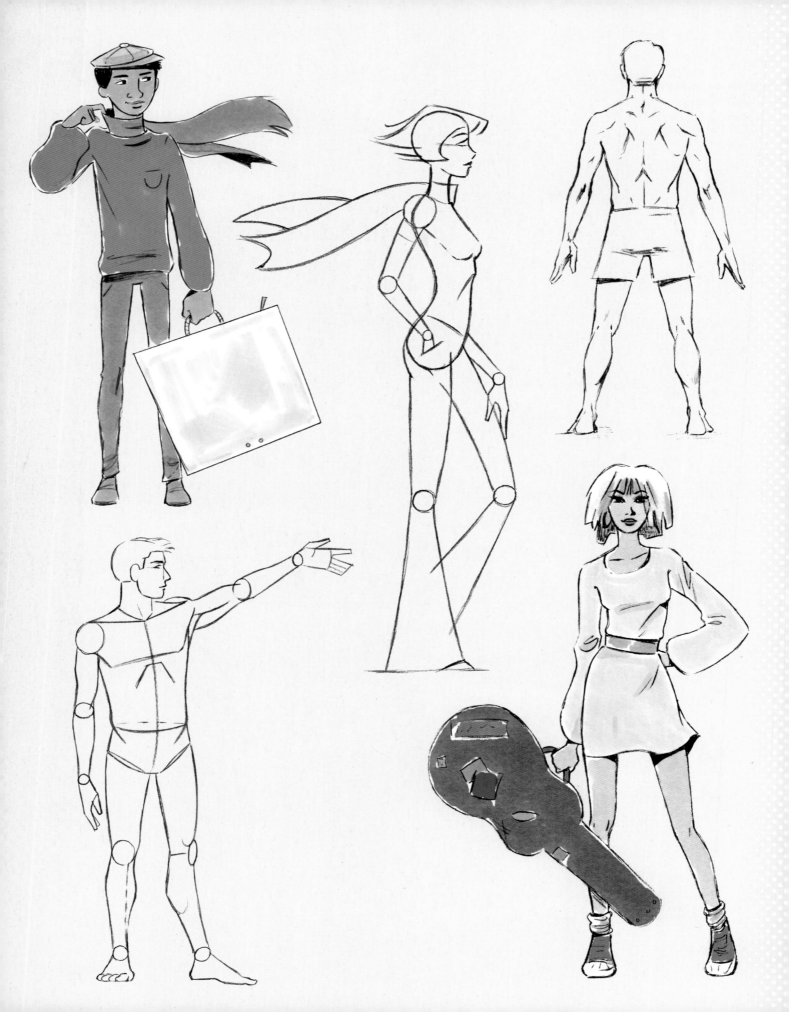

DRAWING THE FIGURE FROM HEAD TO TOE

When you begin to draw the figure from head to toe, you'll want to take a few proportions into consideration. For example, are the legs too short or too long? How about the length of the arms? Many an aspiring artist has drawn a person with great care only to realize that the proportions are off. The way to prevent that from happening is to establish the proportions at the outset. A few simple guidelines will set us in the right direction.

Proportion Guidelines

The complete figure can be broken down into correct proportions by using a few basic guidelines.

Let's see how the guidelines for proportions are applied to a finished figure. Proportions aren't rigid mathematical equations, so relax and use them as general guides.

Top of figure

The halfway point of the body is at the bottom of the hips.

Bottom of figure

Top of figure

TIP
The most important proportion is the halfway point on the human.

The halfway point aligns with the level of the wrists.

The extended fingertips would fall to mid-thigh.

We can add a few more practical proportions to flesh out the figure.

Bottom of figure

Color Version

Overview of the Whole Figure

I will introduce a few practical concepts rather than bogging you down with details. Let's start with the way people generally stand, what it says about the construction of the figure, and how to draw it.

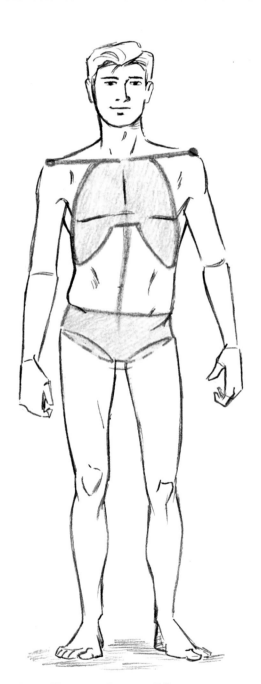

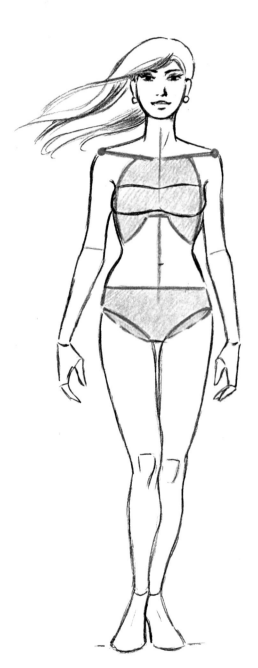

Male Construction

The upper torso can tilt independently of the hips. Even a slight tilt lends vitality to the pose. Notice how the shoulders and chest tilt slightly to the left?

Female Construction

This pose, with the shoulders and chest level, gives the feeling of stability because the upper torso and hips are aligned, with no tilt to the left or to the right.

79

Front View—The Full Figure

Here are a few more nuts and bolts for figure drawing. The more time you spend on the basics, the less you'll have to go back and correct them!

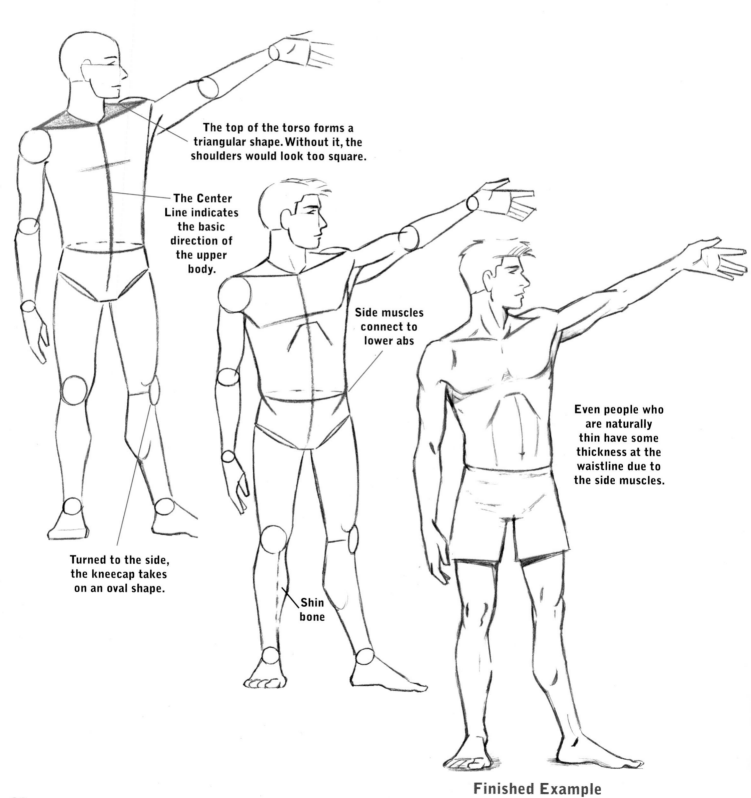

The top of the torso forms a triangular shape. Without it, the shoulders would look too square.

The **Center Line** indicates the basic direction of the upper body.

Side muscles connect to lower abs

Turned to the side, the kneecap takes on an oval shape.

Shin bone

Even people who are naturally thin have some thickness at the waistline due to the side muscles.

Finished Example

Turned to the Right (or Left)

When the body turns, it results in an asymmetrical appearance. And yet, we need to decide where the "true middle" is in order to add the guidelines.

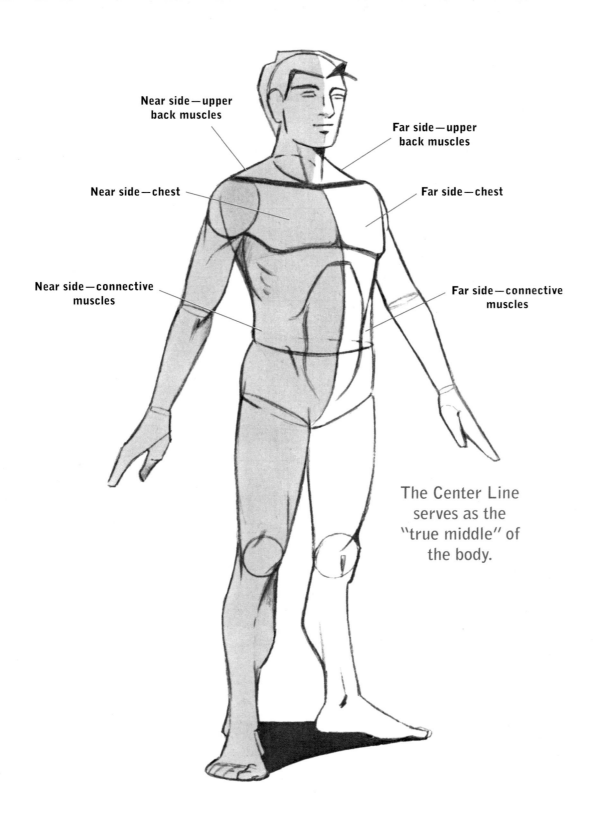

Near side—upper back muscles

Far side—upper back muscles

Near side—chest

Far side—chest

Near side—connective muscles

Far side—connective muscles

The Center Line serves as the "true middle" of the body.

Back View—Helpful Hints

Aspiring artists find the back challenging to draw because they can't see it in the mirror. You could try spinning around so quickly that you catch a glimpse of it. But why make yourself dizzy? Check out these tips instead.

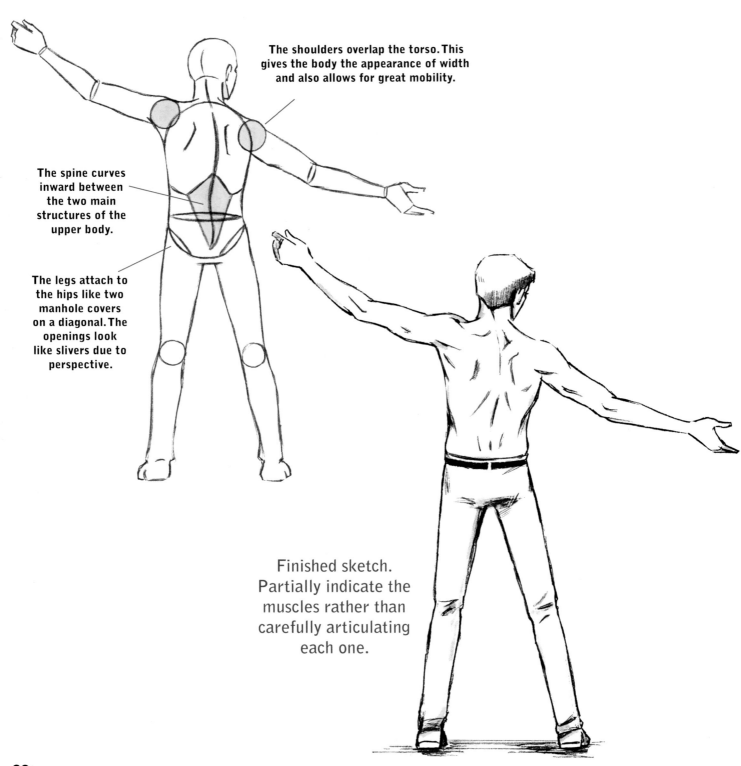

The shoulders overlap the torso. This gives the body the appearance of width and also allows for great mobility.

The spine curves inward between the two main structures of the upper body.

The legs attach to the hips like two manhole covers on a diagonal. The openings look like slivers due to perspective.

Finished sketch. Partially indicate the muscles rather than carefully articulating each one.

Back View—More Ideas

For demonstration purposes, I added definition to the back, but you don't have to. When you construct it solidly and logically, you can leave it plain and uncluttered, and it will still look convincing. Let's review some of the building blocks.

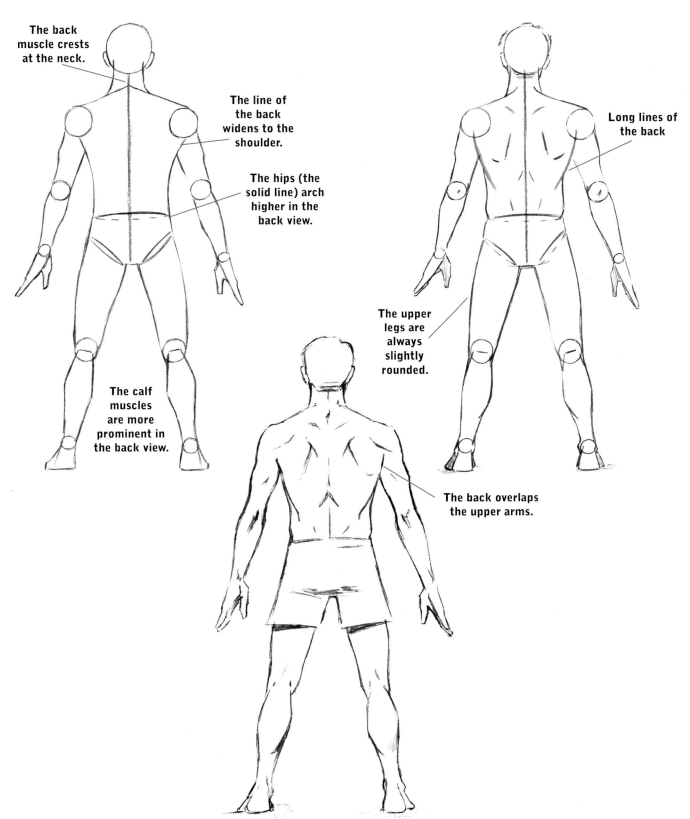

The back muscle crests at the neck.

The line of the back widens to the shoulder.

The hips (the solid line) arch higher in the back view.

The calf muscles are more prominent in the back view.

Long lines of the back

The upper legs are always slightly rounded.

The back overlaps the upper arms.

Tips for Hips

The hips are a significant part of the overall structure of the figure. They tie the upper and lower body together and bear the weight of the head and torso. Most aspiring artists don't give this section much thought, but following a few easy hints will elevate the level of your drawings.

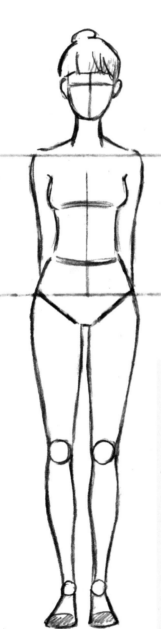

The shoulders and hips are good measuring points for making sure the figure is level.

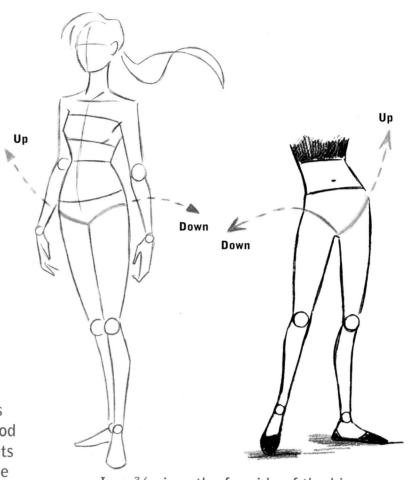

In a ¾ view, the far side of the hips curves up, and the near side curves down.

Level of the Hips

Don't include the waistline with the hips. The waist is fairly high on the figure, but the hips are low. The purpose of the hips is to act as a cradle for the internal organs and as a platform for the legs. The purpose of the waistline is to allow for second helpings. That's not the technical explanation.

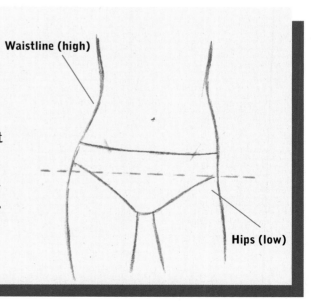

Waistline (high)

Hips (low)

The Sweep of the Hips

When a figure stands, the hips generally sweep back. This has the effect of stretching the front of the torso, which creates a long line along the front of the body.

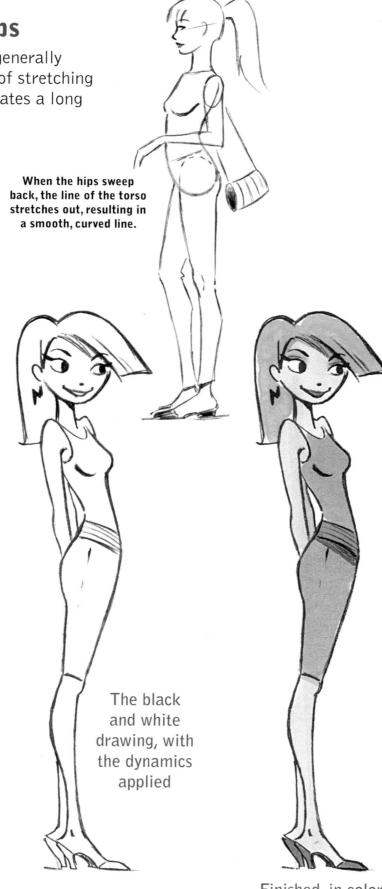

When the hips sweep back, the line of the torso stretches out, resulting in a smooth, curved line.

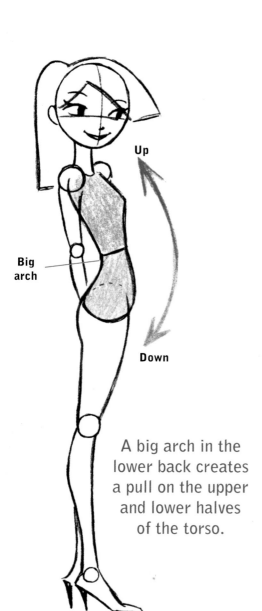

Up

Down

Big arch

A big arch in the lower back creates a pull on the upper and lower halves of the torso.

The black and white drawing, with the dynamics applied

Finished, in color

Hip Action—Step by Step

There's often the temptation to avoid exaggerating an area, such as the hips. But the hips are one area where exaggeration is the key to success. Let's see how it's done.

TIP
To make something look natural, do less, not more.

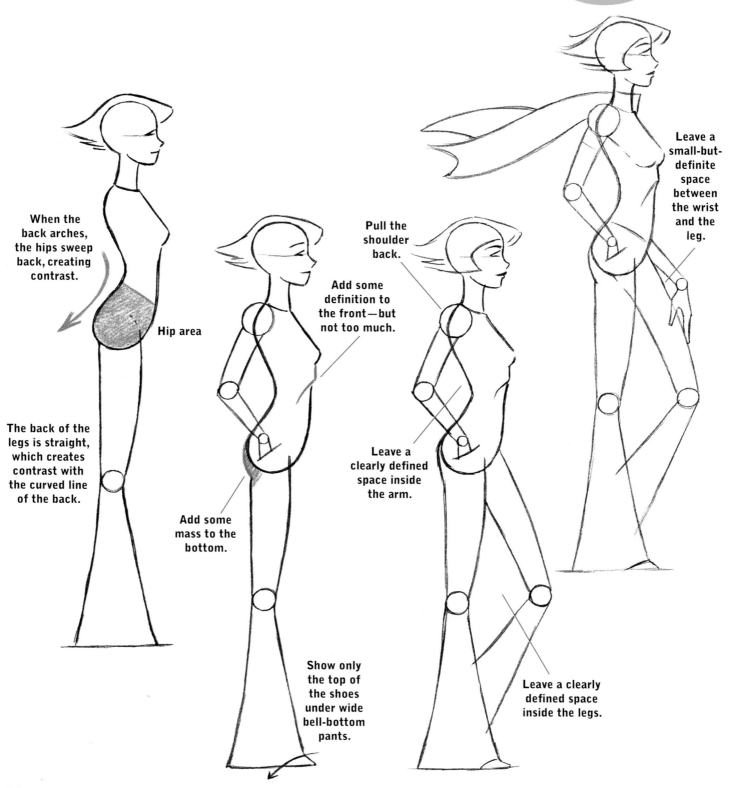

When the back arches, the hips sweep back, creating contrast.

Hip area

The back of the legs is straight, which creates contrast with the curved line of the back.

Add some mass to the bottom.

Show only the top of the shoes under wide bell-bottom pants.

Pull the shoulder back.

Add some definition to the front—but not too much.

Leave a clearly defined space inside the arm.

Leave a clearly defined space inside the legs.

Leave a small-but-definite space between the wrist and the leg.

86

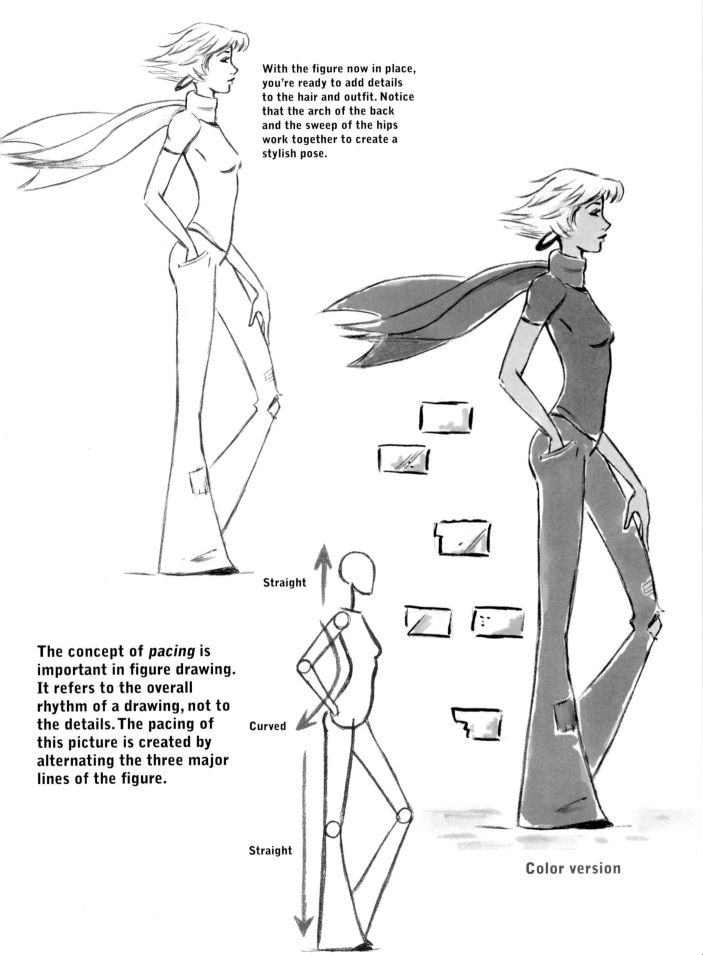

With the figure now in place, you're ready to add details to the hair and outfit. Notice that the arch of the back and the sweep of the hips work together to create a stylish pose.

The concept of *pacing* is important in figure drawing. It refers to the overall rhythm of a drawing, not to the details. The pacing of this picture is created by alternating the three major lines of the figure.

Straight

Curved

Straight

Color version

Tips for Drawing Legs

I think you'll enjoy this topic because the techniques are so intuitive. You'll use these techniques all the time and wonder why you didn't think of them before. When it clicks, you've got it.

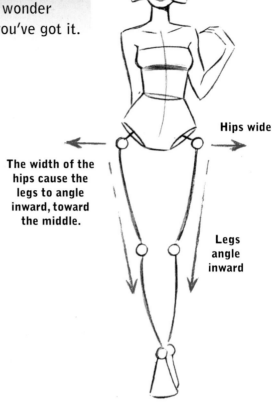

Hips wide

The width of the hips cause the legs to angle inward, toward the middle.

Legs angle inward

Angle of the Legs

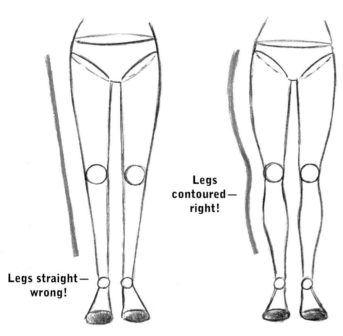

Legs contoured— right!

Legs straight— wrong!

Contour of the Legs

Figuring Out the Sections of the Leg

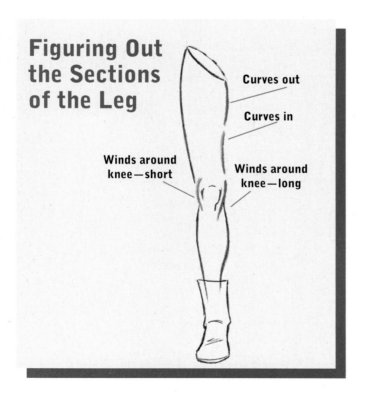

Curves out

Curves in

Winds around knee—short

Winds around knee—long

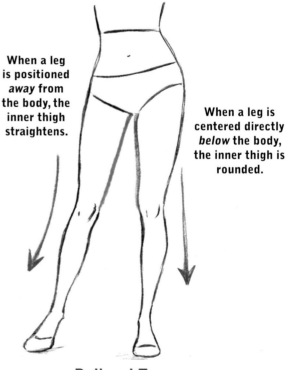

When a leg is positioned *away* from the body, the inner thigh straightens.

When a leg is centered directly *below* the body, the inner thigh is rounded.

Pull and Tug

Simple Deconstruction

The legs are a piece of machinery made of different components. Once you know how they're assembled, you can put them together with ease.

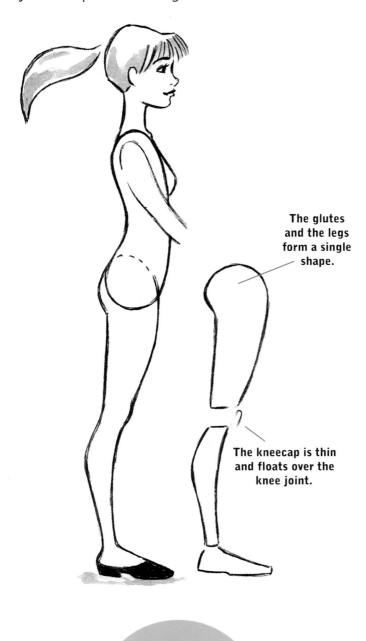

The glutes and the legs form a single shape.

The kneecap is thin and floats over the knee joint.

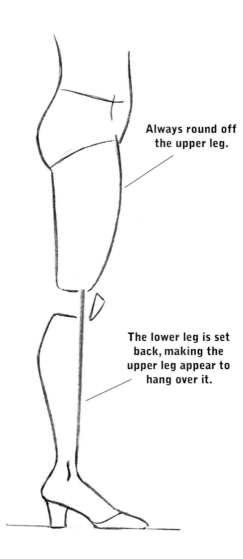

Always round off the upper leg.

The lower leg is set back, making the upper leg appear to hang over it.

TIP

The straight leg shifts position below the knee.

How to Hyperextend the Knee

When you put pressure on a locked joint, it *hyperextends,* which is a fancy way of saying that it bends slightly in the "wrong" direction. We've all seen someone hyperextend an elbow, but it happens to knees, too. It's a useful technique for drawing appealing and stylish poses. Let's try it out.

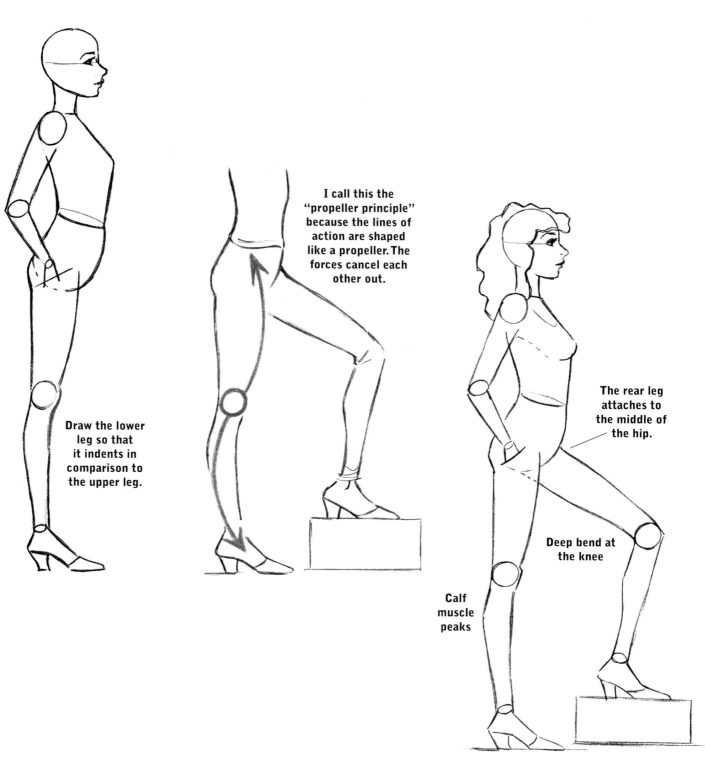

Draw the lower leg so that it indents in comparison to the upper leg.

I call this the "propeller principle" because the lines of action are shaped like a propeller. The forces cancel each other out.

The rear leg attaches to the middle of the hip.

Deep bend at the knee

Calf muscle peaks

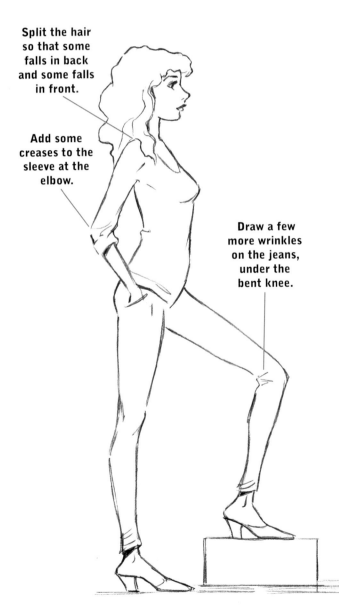

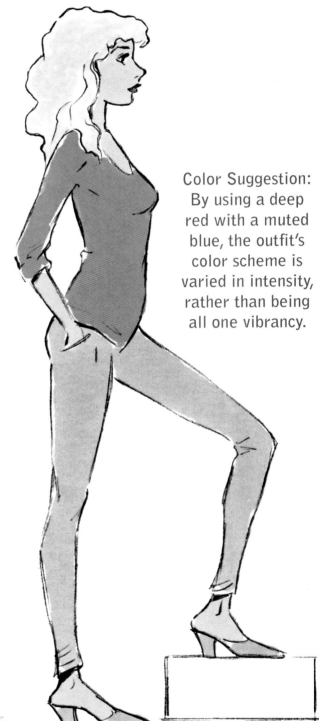

COLOR TIP

Don't only think of which colors to use, but which *intensity* of colors to use.

Split the hair so that some falls in back and some falls in front.

Add some creases to the sleeve at the elbow.

Draw a few more wrinkles on the jeans, under the bent knee.

Color Suggestion: By using a deep red with a muted blue, the outfit's color scheme is varied in intensity, rather than being all one vibrancy.

The Height Line

This is a hugely helpful trick to use. Everyone who has ever drawn a figure has, at one time or another, run out of room on the page, leaving no space to draw the feet. If this happens, you either have to start all over again or pretend you meant to draw the figure without feet. Neither is a good option.

This technique works every time: Begin your drawing with a vertical sketch line the length of the figure you want to draw. Let's see how it works.

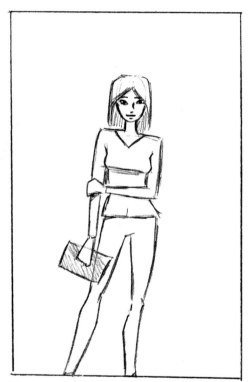

You've run out of room at the bottom of the page!

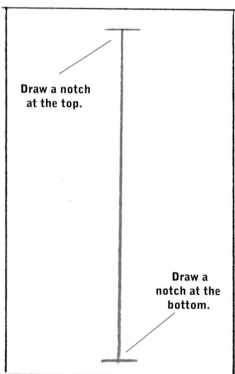

Draw a notch at the top.

Draw a notch at the bottom.

Now you've got a plan. Start by drawing a vertical line the length of the envisioned figure.

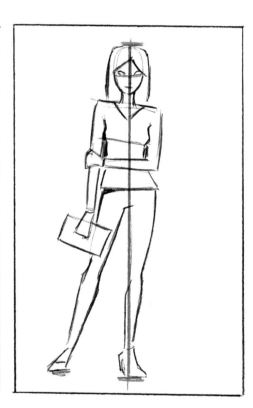

Draw the rough figure within the top and bottom notches of the Height Line.

The Height Line Step-by-Step

Now let's incorporate the Height Line into our step-by-step construction of a figure. Keep in mind that the height line is not part of the basic construction of the figure in the way that the Center Line is. Use the Height Line to get started, and then discard it.

Sketch the Height Line, and add top and bottom notches.

Draw a simple mannequin for placement, making sure that it fits within the brackets of the Height Line.

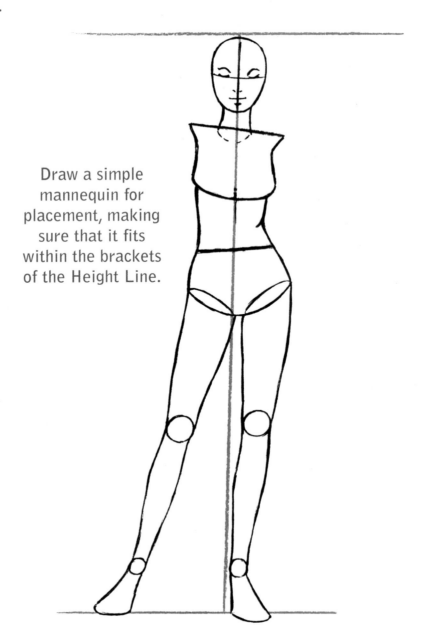

Once the height is established, erase the guideline and continue to build the figure.

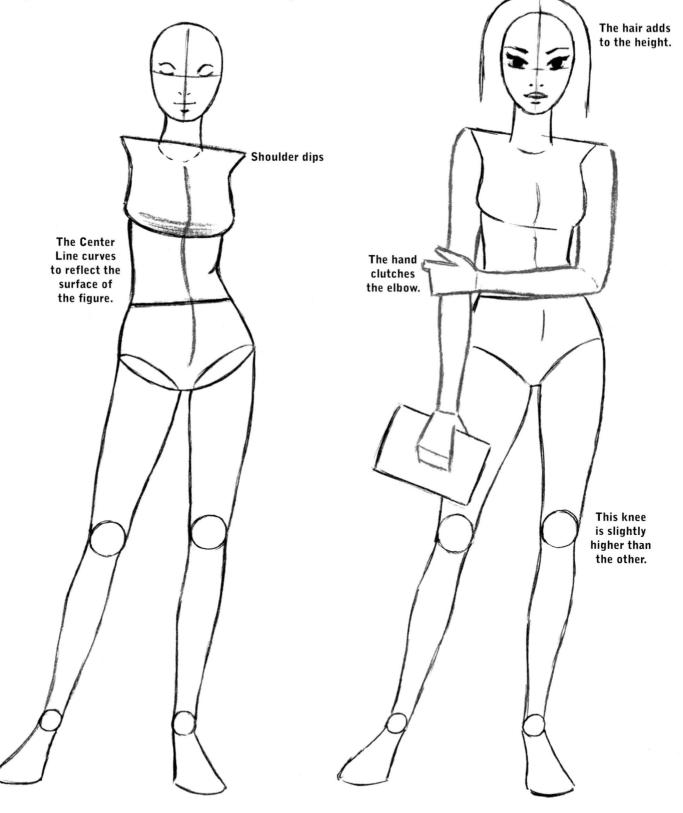

Shoulder dips

The Center Line curves to reflect the surface of the figure.

The hair adds to the height.

The hand clutches the elbow.

This knee is slightly higher than the other.

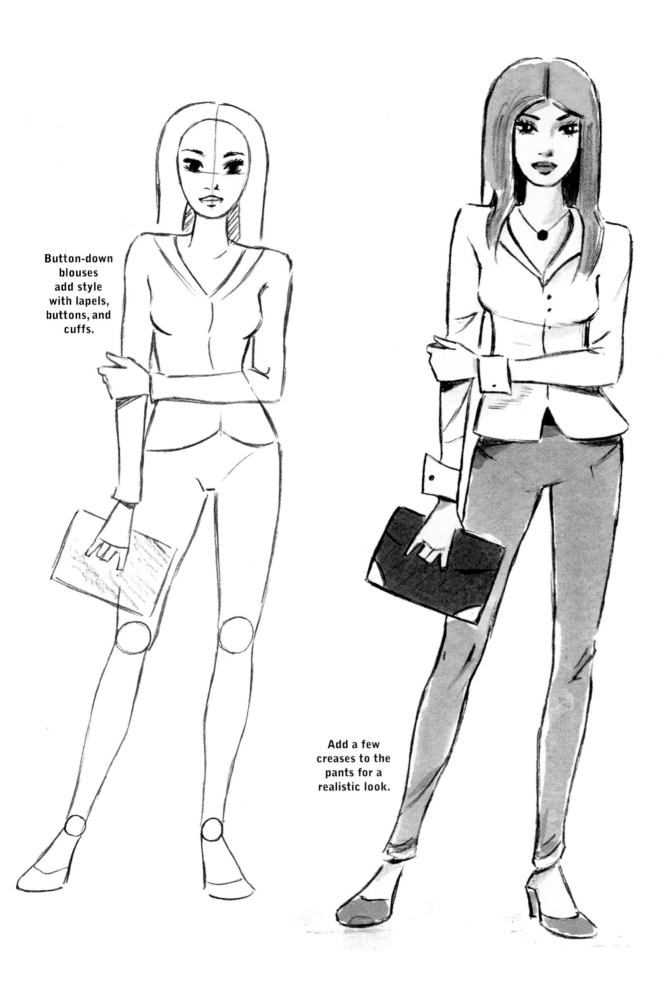

Button-down blouses add style with lapels, buttons, and cuffs.

Add a few creases to the pants for a realistic look.

95

When in Doubt, Take a Step Back

Every artist gets stuck now and then. When the gremlin strikes, here's what to do: Simplify the body to create a combination mannequin and stick figure. This makes it easy to plot out the pose and removes the complications. Once you've got the simplified construction the way you like it, you can start to fill it out.

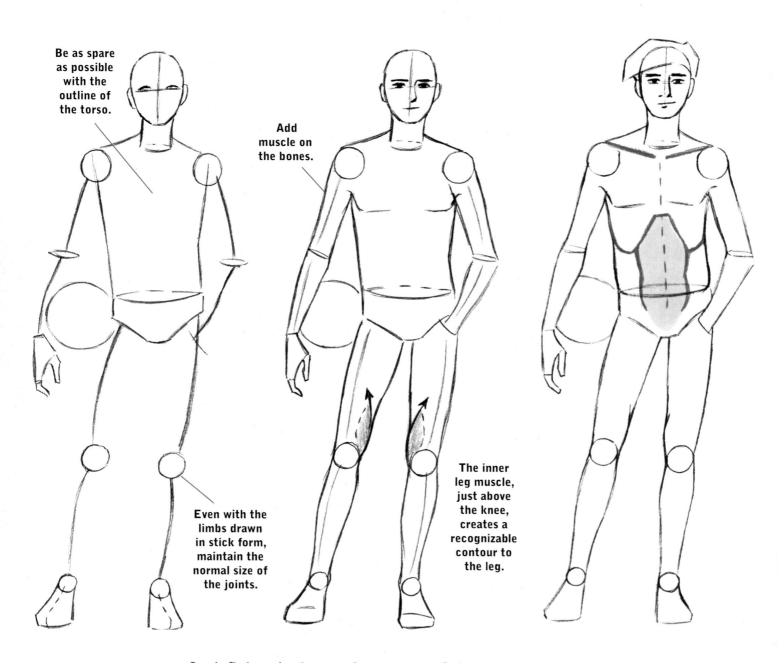

Be as spare as possible with the outline of the torso.

Add muscle on the bones.

Even with the limbs drawn in stick form, maintain the normal size of the joints.

The inner leg muscle, just above the knee, creates a recognizable contour to the leg.

In defining the internal structure of the torso, you don't have to be as precise or complete as this. Use as much detail as you need to give your drawing a sense of authority.

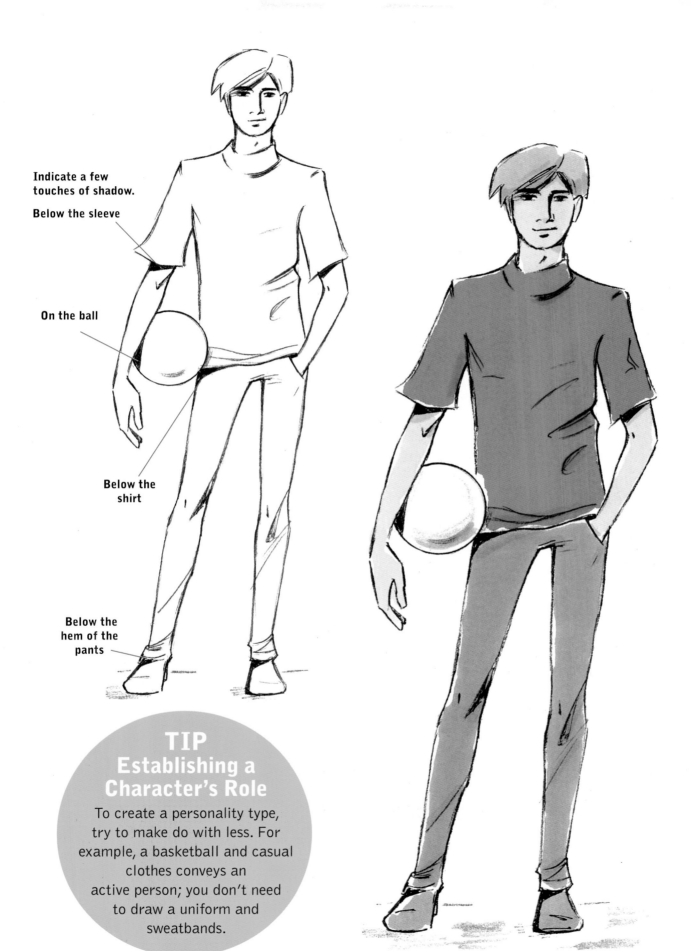

Indicate a few touches of shadow.

Below the sleeve

On the ball

Below the shirt

Below the hem of the pants

TIP
Establishing a Character's Role

To create a personality type, try to make do with less. For example, a basketball and casual clothes conveys an active person; you don't need to draw a uniform and sweatbands.

From the Back

In the back view, the Center Line serves as a unifying element that holds the sections of the body together. It also divides the figure into a near side and a far side of the head and torso. You can draw it up the neck and even over the head.

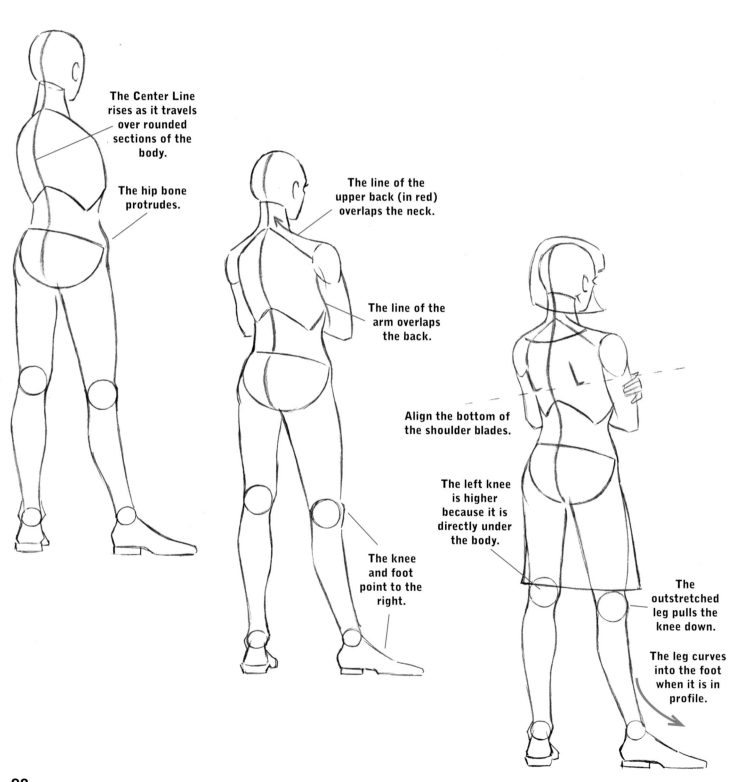

The Center Line rises as it travels over rounded sections of the body.

The hip bone protrudes.

The line of the upper back (in red) overlaps the neck.

The line of the arm overlaps the back.

Align the bottom of the shoulder blades.

The knee and foot point to the right.

The left knee is higher because it is directly under the body.

The outstretched leg pulls the knee down.

The leg curves into the foot when it is in profile.

TIP

The back angle doesn't have to be flat. By turning the figure slightly to the left or right, you add interest.

A layperson may not see it, but all of the previous steps that went into creating the construction for this figure is directly responsible for why it looks so natural.

People and Props

An interesting prop can contribute to an interesting character. The guitar case is a big and bold choice. It also pulls down on the arm, causing her body to compensate, which results in a dynamic posture.

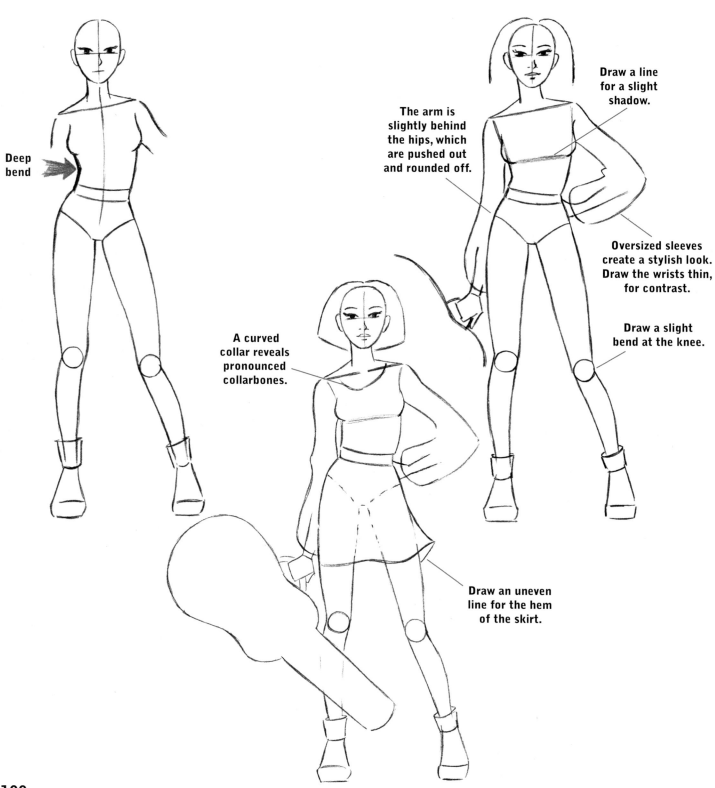

Deep bend

The arm is slightly behind the hips, which are pushed out and rounded off.

Draw a line for a slight shadow.

Oversized sleeves create a stylish look. Draw the wrists thin, for contrast.

Draw a slight bend at the knee.

A curved collar reveals pronounced collarbones.

Draw an uneven line for the hem of the skirt.

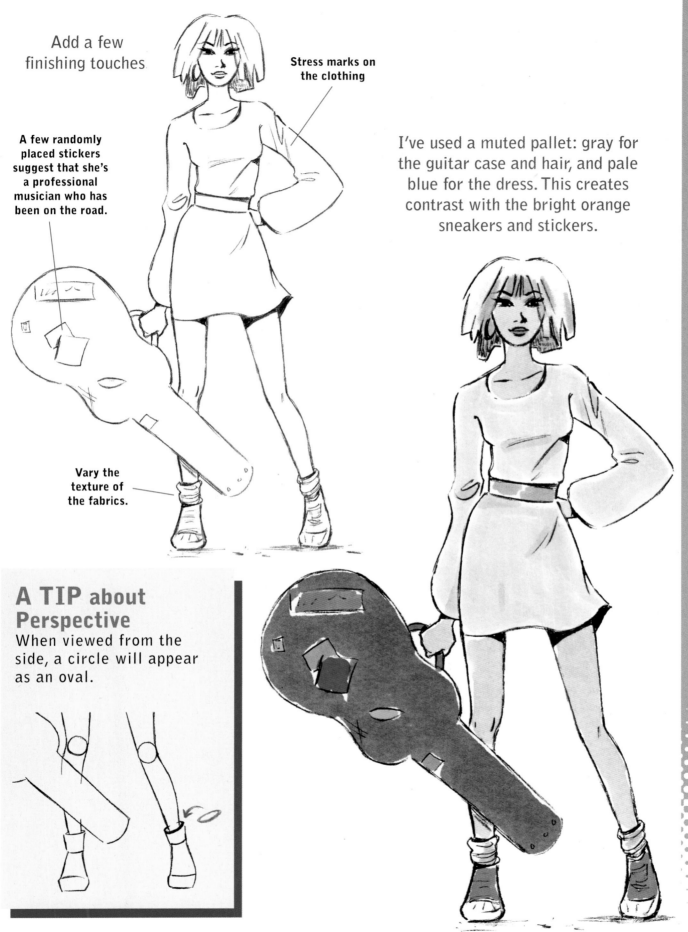

Add a few finishing touches.

Stress marks on the clothing

A few randomly placed stickers suggest that she's a professional musician who has been on the road.

Vary the texture of the fabrics.

I've used a muted pallet: gray for the guitar case and hair, and pale blue for the dress. This creates contrast with the bright orange sneakers and stickers.

A TIP about Perspective

When viewed from the side, a circle will appear as an oval.

The Art Student

Artists are a festival of contradictions. Their clothes are colorful, except when they wear all black. They have a relaxed manner about them, except when they're freaking out. And they possess a keenly observant eye, unless they're lost in a daydream. All in all, it's a fun character to draw. Let's take a look.

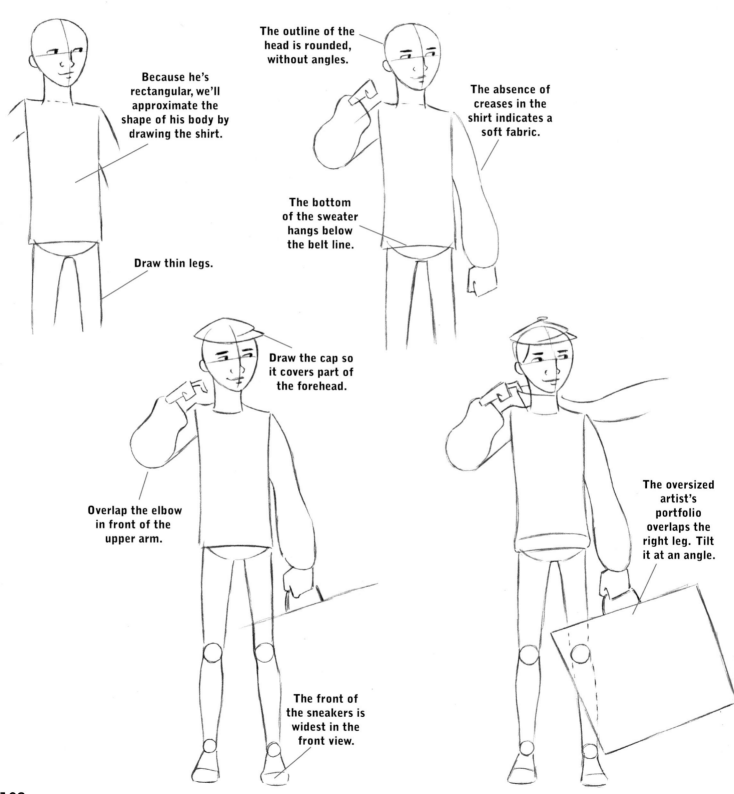

Because he's rectangular, we'll approximate the shape of his body by drawing the shirt.

Draw thin legs.

The outline of the head is rounded, without angles.

The absence of creases in the shirt indicates a soft fabric.

The bottom of the sweater hangs below the belt line.

Draw the cap so it covers part of the forehead.

Overlap the elbow in front of the upper arm.

The front of the sneakers is widest in the front view.

The oversized artist's portfolio overlaps the right leg. Tilt it at an angle.

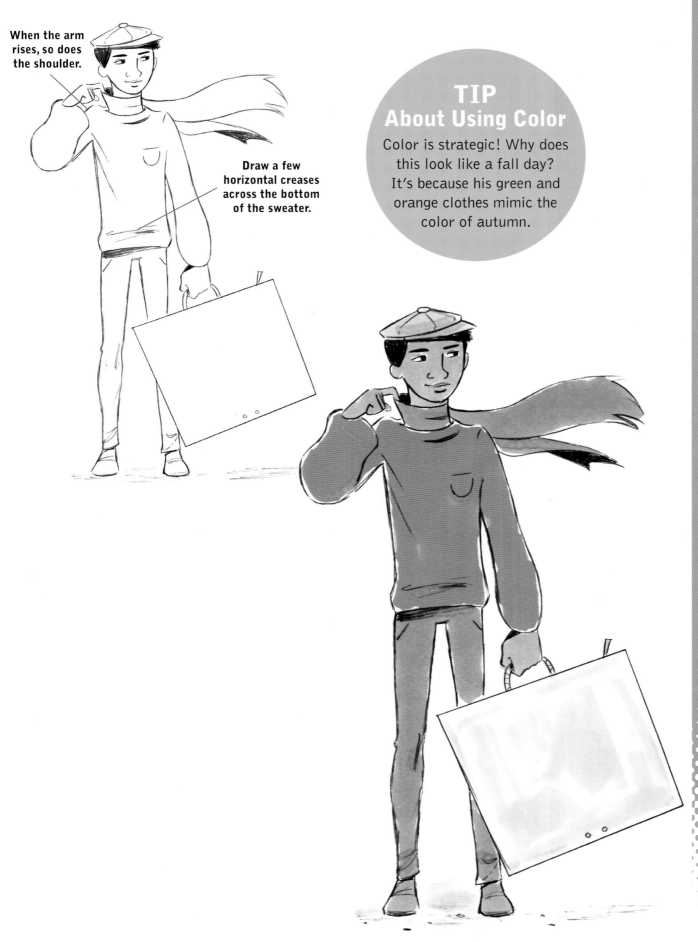

When the arm rises, so does the shoulder.

Draw a few horizontal creases across the bottom of the sweater.

TIP
About Using Color
Color is strategic! Why does this look like a fall day? It's because his green and orange clothes mimic the color of autumn.

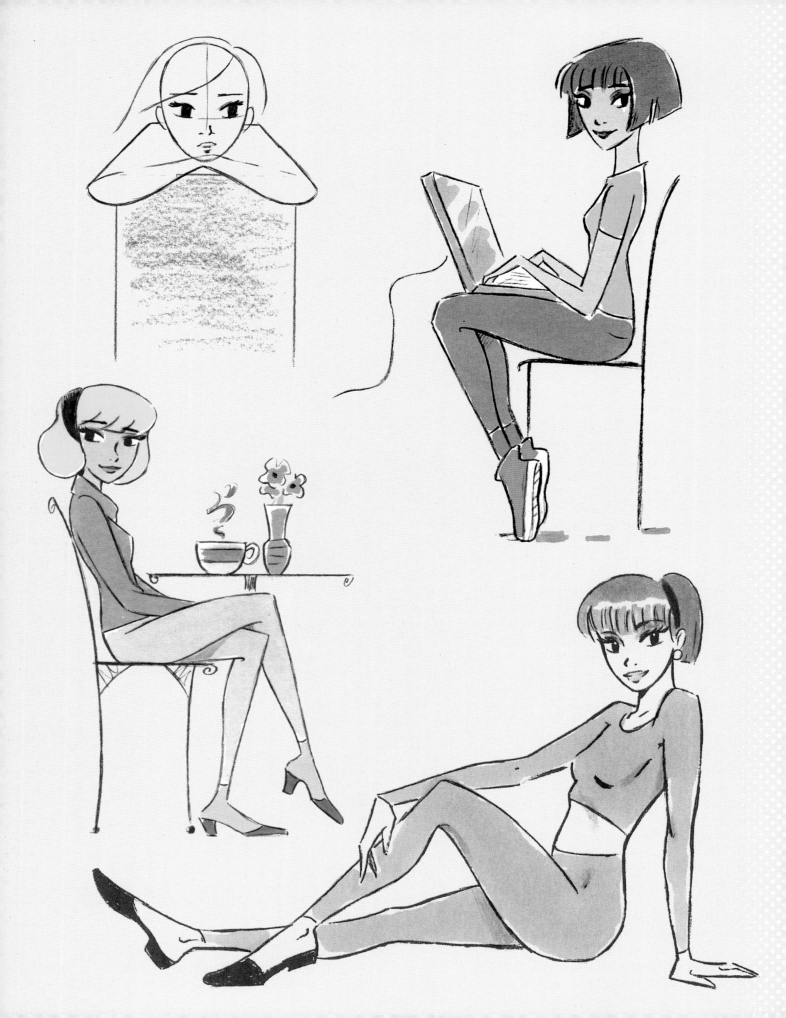

SITTING POSES

Do you avoid drawing sitting poses? I can help you break them down into a few simple elements so that you can draw them effectively. Here's the first step: Toss out the idea of drawing a flowing pose. When a person sits, the upper body and the lower body don't necessarily flow together. In fact, they are often at right angles to each other. Therefore, if you're trying to create a flow, you're trying too hard. Let's make it simple.

Sitting—Legs Together

A sitting pose is one place where mirroring the leg positions works. Notice that the torso is vertical, while the upper legs are horizontal.

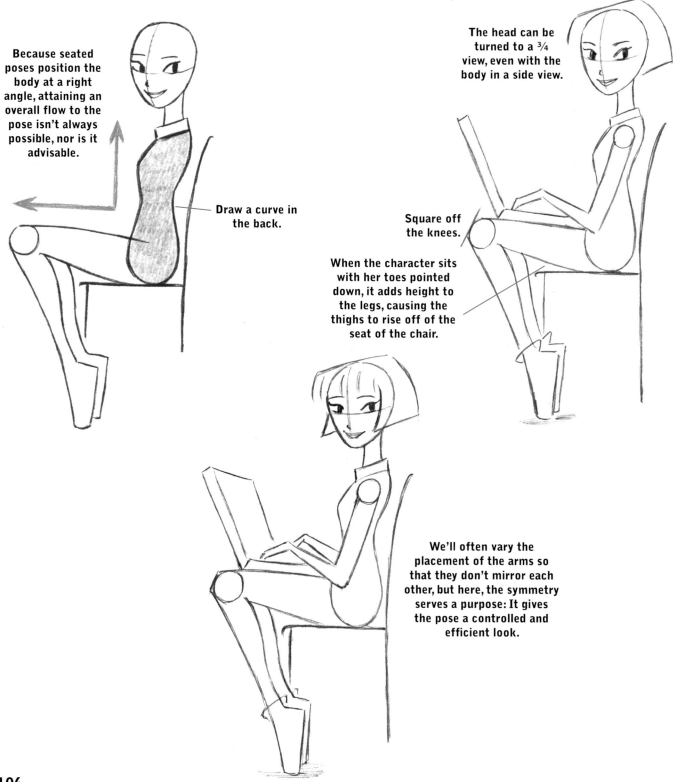

Because seated poses position the body at a right angle, attaining an overall flow to the pose isn't always possible, nor is it advisable.

Draw a curve in the back.

The head can be turned to a ¾ view, even with the body in a side view.

Square off the knees.

When the character sits with her toes pointed down, it adds height to the legs, causing the thighs to rise off of the seat of the chair.

We'll often vary the placement of the arms so that they don't mirror each other, but here, the symmetry serves a purpose: It gives the pose a controlled and efficient look.

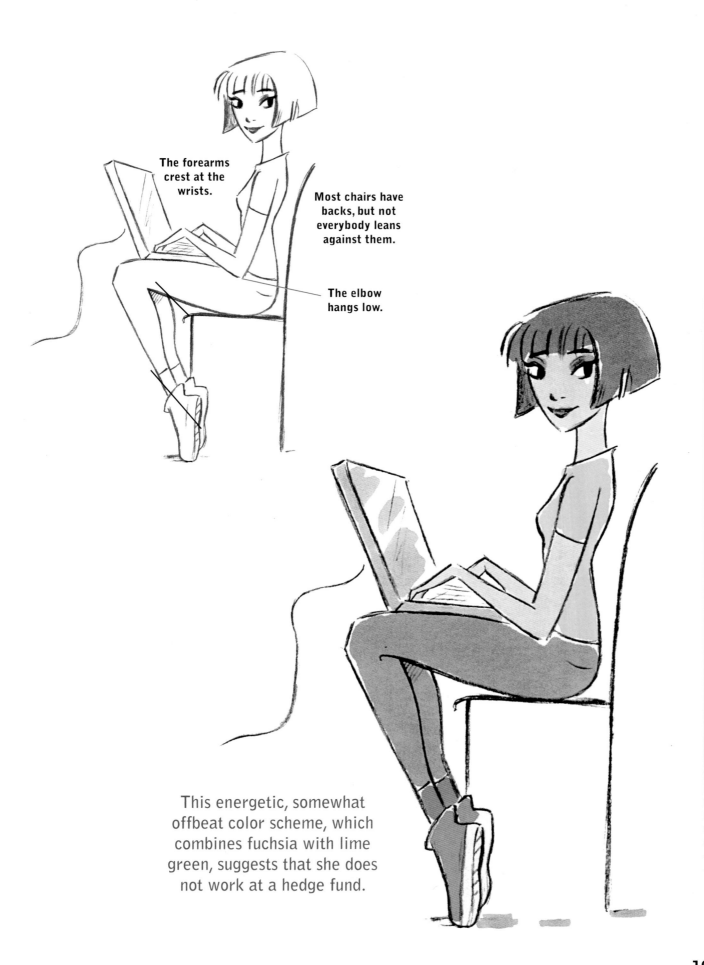

The forearms crest at the wrists.

Most chairs have backs, but not everybody leans against them.

The elbow hangs low.

This energetic, somewhat offbeat color scheme, which combines fuchsia with lime green, suggests that she does not work at a hedge fund.

Sitting—Legs Crossed

Now we'll draw a reclining torso with the legs crossed. The backs of chairs aren't very far back. As a consequence, the torso doesn't stretch and retains its usual shape.

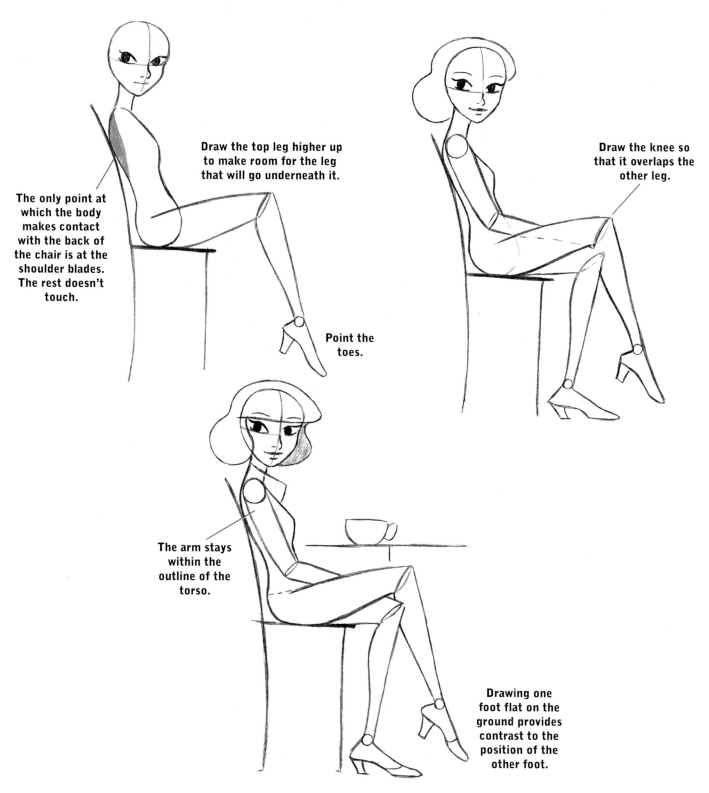

Draw the top leg higher up to make room for the leg that will go underneath it.

The only point at which the body makes contact with the back of the chair is at the shoulder blades. The rest doesn't touch.

Point the toes.

Draw the knee so that it overlaps the other leg.

The arm stays within the outline of the torso.

Drawing one foot flat on the ground provides contrast to the position of the other foot.

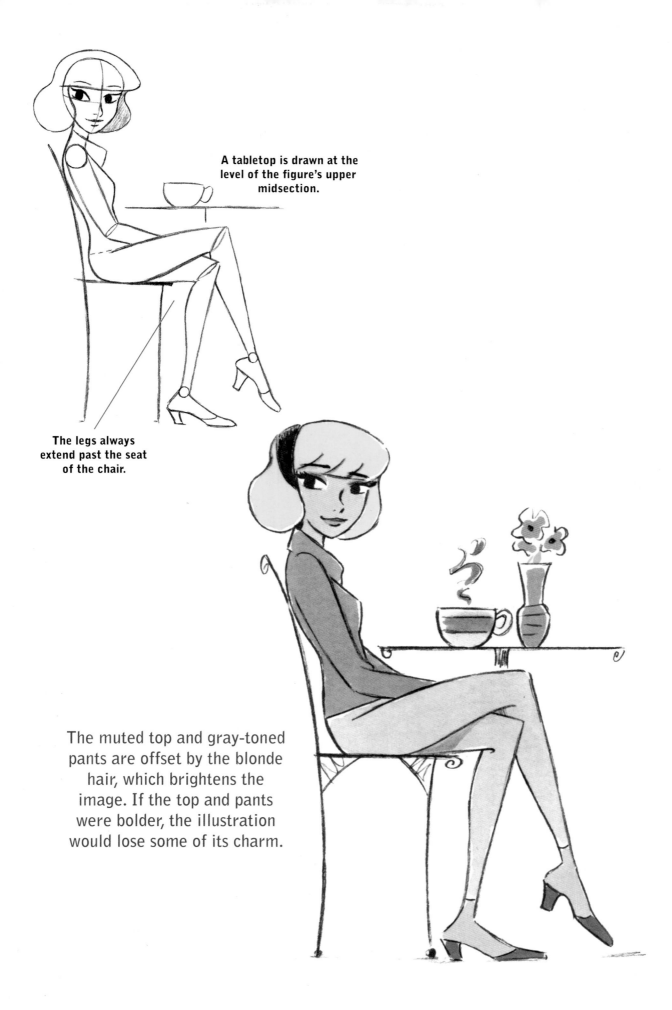

A tabletop is drawn at the level of the figure's upper midsection.

The legs always extend past the seat of the chair.

The muted top and gray-toned pants are offset by the blonde hair, which brightens the image. If the top and pants were bolder, the illustration would lose some of its charm.

Facing Backward in a Chair

This pose is a good change of pace and is effective for conveying a range of expressions from casual to reflective. It's logically constructed with the hands and head coming together at a single point over the wrists. Here's how it's typically done.

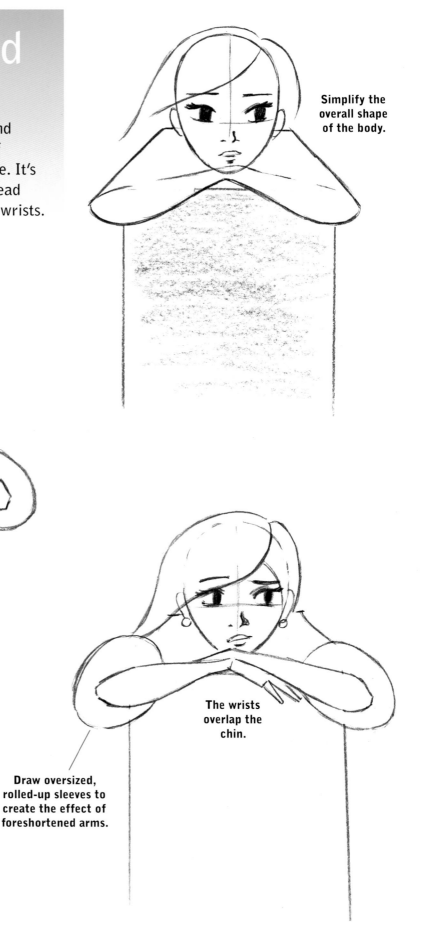

Simplify the overall shape of the body.

The level of the shoulders is high.

Center the wrists under the head.

The elbows fall below the top of the chair.

The wrists overlap the chin.

Draw oversized, rolled-up sleeves to create the effect of foreshortened arms.

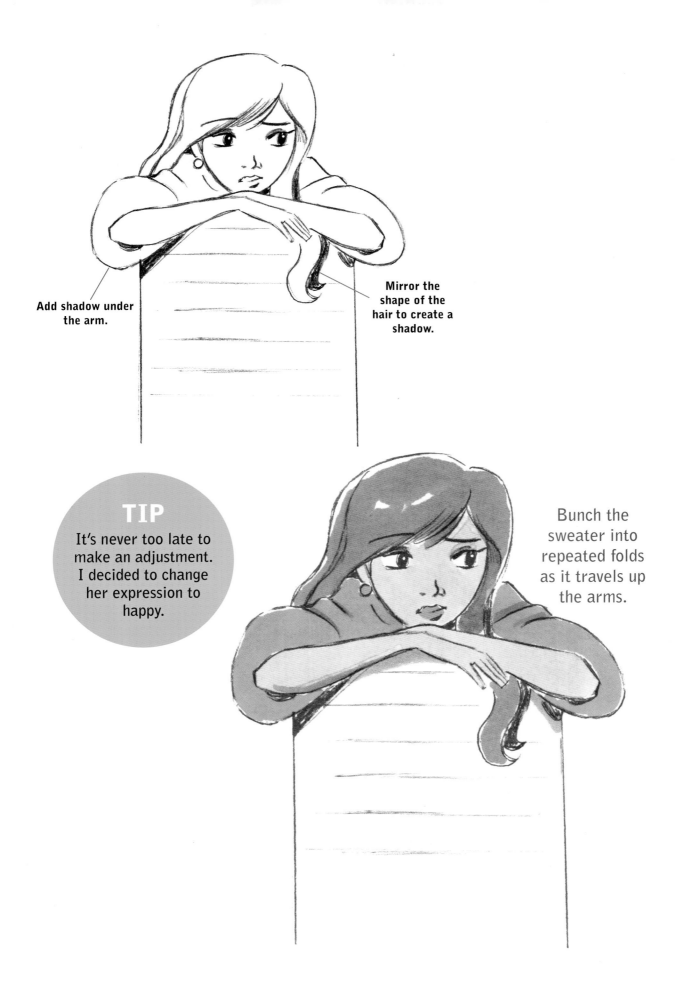

Add shadow under the arm.

Mirror the shape of the hair to create a shadow.

TIP

It's never too late to make an adjustment. I decided to change her expression to happy.

Bunch the sweater into repeated folds as it travels up the arms.

Kneeling

We've established that a sitting position doesn't always create a single, flowing line as the basis for the figure. This is true for a kneeling position as well. That's because there's an abrupt change of angle from the torso to the legs. But that doesn't mean that some individual lines of the figure can't flow. In this demonstration, you'll see how the three defining lines of the figure flow to create an appealing look.

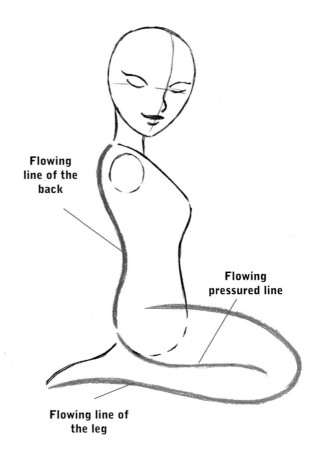

Flowing line of the back

Flowing pressured line

Flowing line of the leg

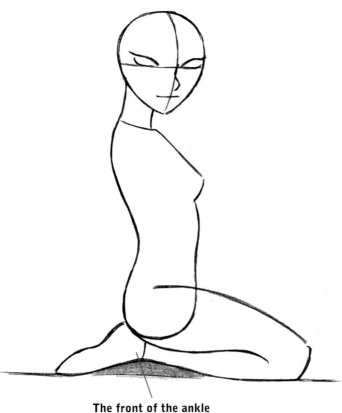

The front of the ankle doesn't touch the ground.

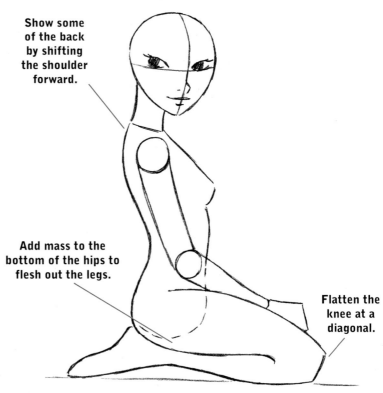

Show some of the back by shifting the shoulder forward.

Add mass to the bottom of the hips to flesh out the legs.

Flatten the knee at a diagonal.

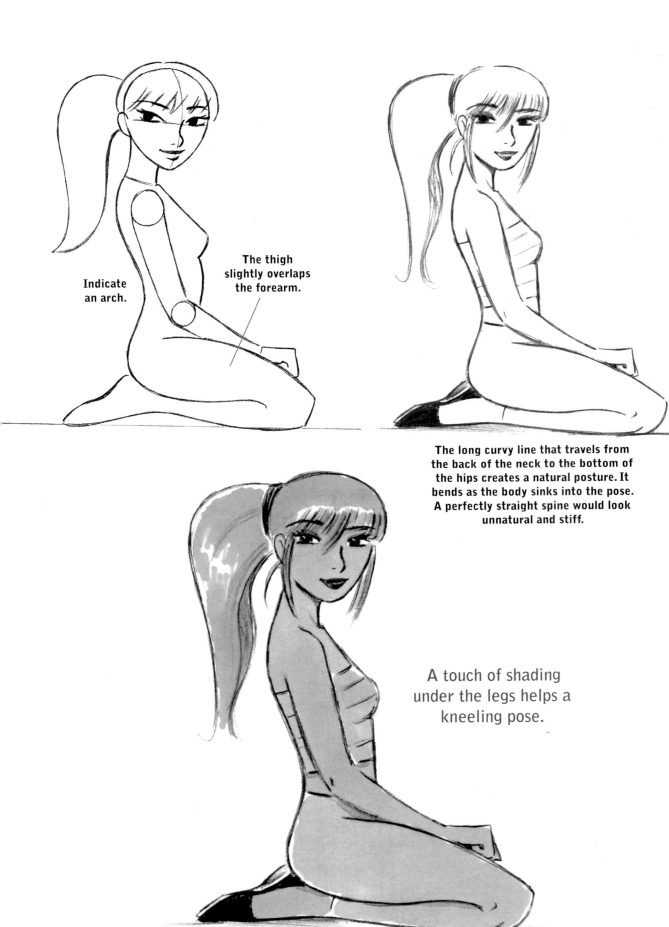

Indicate an arch.

The thigh slightly overlaps the forearm.

The long curvy line that travels from the back of the neck to the bottom of the hips creates a natural posture. It bends as the body sinks into the pose. A perfectly straight spine would look unnatural and stiff.

A touch of shading under the legs helps a kneeling pose.

113

Floor Sitting

Everyone has sat on the floor, or has tripped over someone who has. To make this pose convincing, the elbow of the supporting arm needs to appear hyperextended. It carries the weight of the head and torso, which is not an insignificant amount. How can we show these forces at work, visually? We'll start by drawing the elbow locked with a slight backward bend.

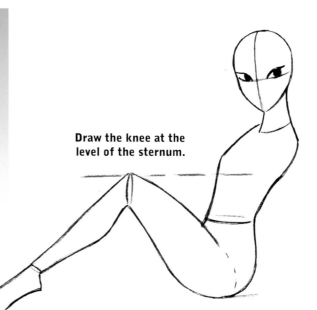

Draw the knee at the level of the sternum.

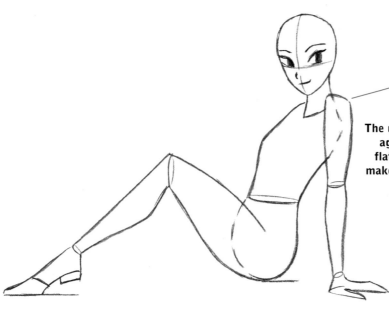

The shoulder takes on an angular shape when it's pushed up

The upper arm presses against the body, flattening it, which makes it appear wider.

The Hyperextended Arm

The upper arm curves around to the elbow and travels straight down to the hand.

114

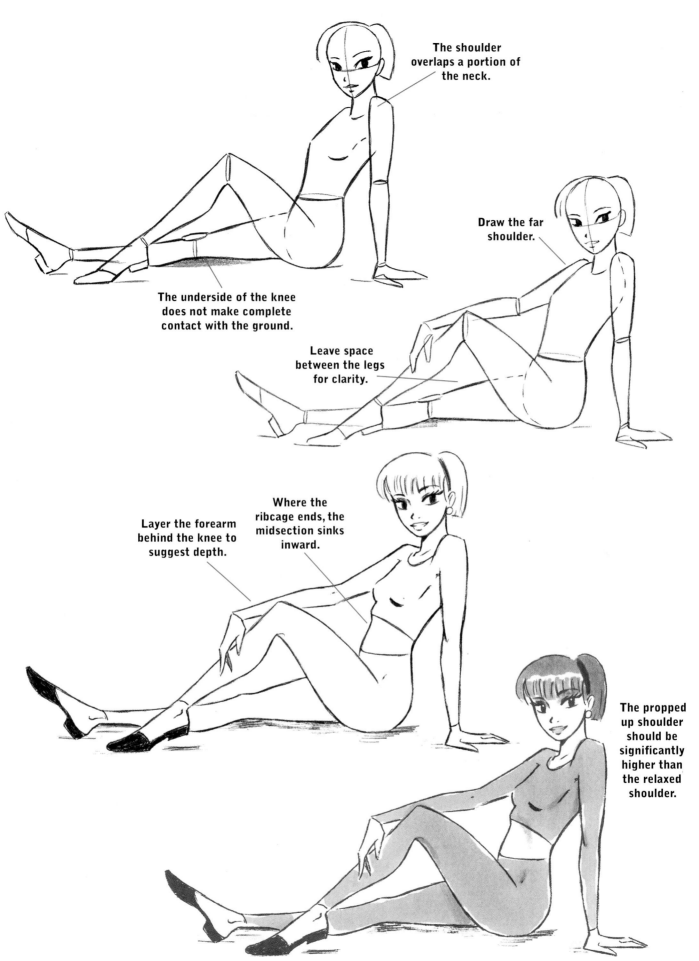

The shoulder overlaps a portion of the neck.

Draw the far shoulder.

The underside of the knee does not make complete contact with the ground.

Leave space between the legs for clarity.

Where the ribcage ends, the midsection sinks inward.

Layer the forearm behind the knee to suggest depth.

The propped up shoulder should be significantly higher than the relaxed shoulder.

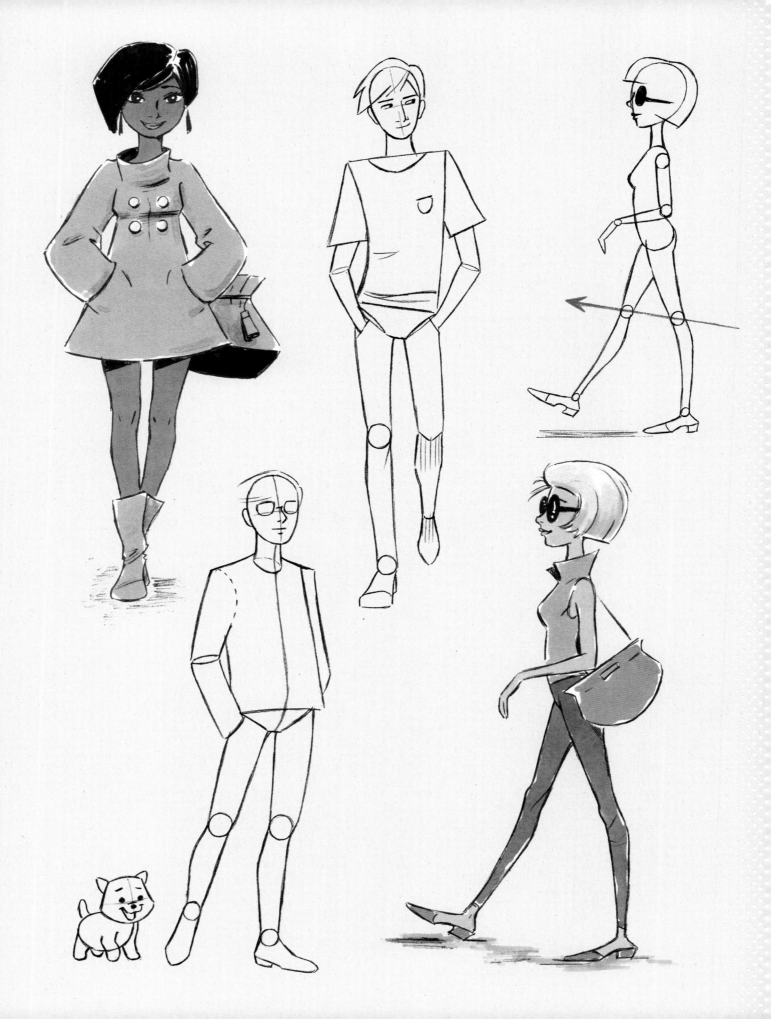

Walking Poses

Walking creates a naturally balanced pose. For example, one foot steps forward as the other moves back. Because of this, there's a natural rhythm that is intuitive to draw. Walking poses add a touch of action to our repertoire of standing and sitting poses.

Walking: Legs Crossed— Front Angle

When beginners draw a person walking, they generally use a side pose. But a front view is actually the simpler choice because only modest leg action is required. Let's draw the walk in midstride to give the pose a spontaneous quality.

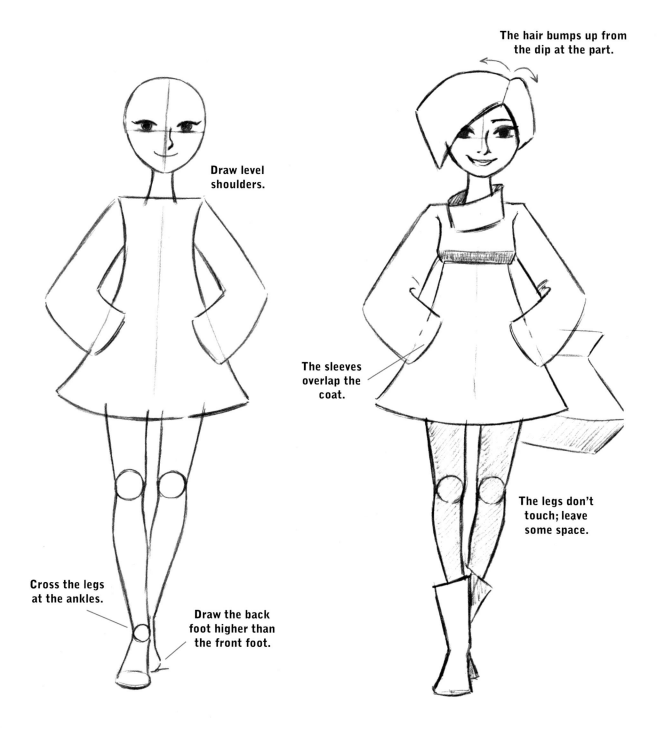

The hair bumps up from the dip at the part.

Draw level shoulders.

The sleeves overlap the coat.

The legs don't touch; leave some space.

Cross the legs at the ankles.

Draw the back foot higher than the front foot.

TIP
About Drawing Sleeves

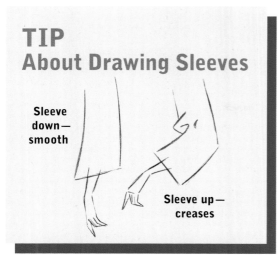

Sleeve down— smooth

Sleeve up— creases

Indicate some shadows:

Note the contrast created by this pose: The arms are held out wide, while the legs are positioned narrowly together.

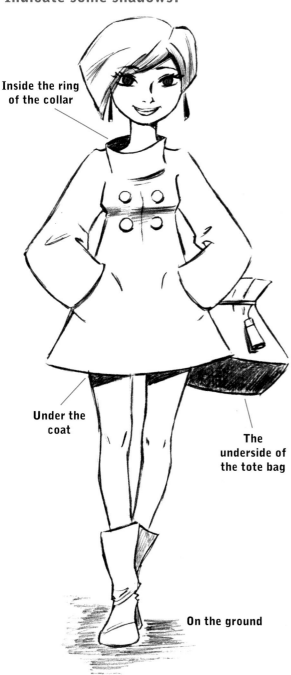

Inside the ring of the collar

Under the coat

The underside of the tote bag

On the ground

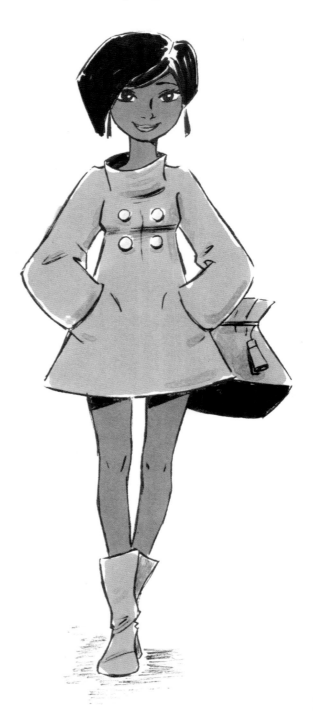

Walking: Legs Apart—Front Angle

Another easy way to draw a walk in the front view is to lift one foot off the ground, bend the knee slightly, and add significant perspective so it appears to shorten. Here are a few more techniques that contribute to a convincing pose.

Diagram of a Walk
It's helpful to see how all of the dynamics come together in one figure.

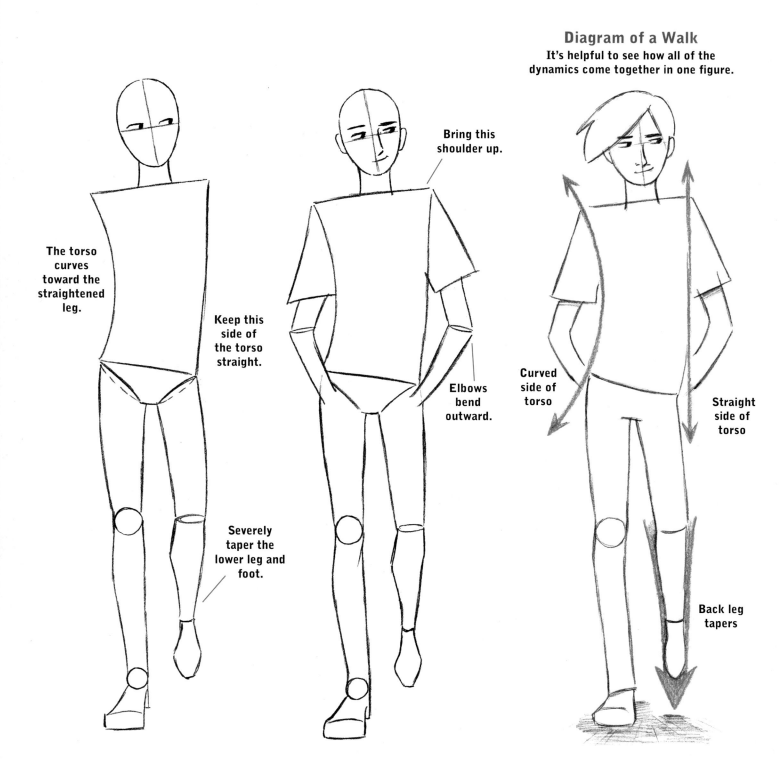

The torso curves toward the straightened leg.

Keep this side of the torso straight.

Severely taper the lower leg and foot.

Bring this shoulder up.

Elbows bend outward.

Curved side of torso

Straight side of torso

Back leg tapers

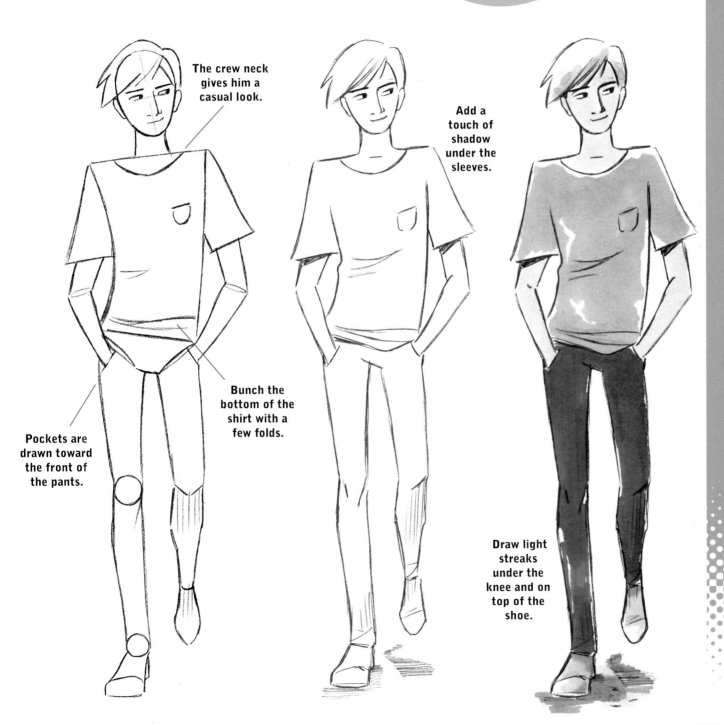

TIP for Drawing the Walk
Draw a shadow under *both* feet. This creates the illusion of weight for the figure.

The crew neck gives him a casual look.

Add a touch of shadow under the sleeves.

Bunch the bottom of the shirt with a few folds.

Pockets are drawn toward the front of the pants.

Draw light streaks under the knee and on top of the shoe.

Walking—3/4 Angle

The three-quarter view can be tricky if you try to do too much with it. Remember, this is a walk, not a run. Simply by drawing one leg up, you're most of the way there. The other important element is to point both feet in different directions. People sometimes wonder, "How do I draw a walk so it looks as if it has momentum?" But a walk usually doesn't have significant momentum. Most people don't lean into a walk. Even this guy's Pomeranian walks in a way that conserves movement.

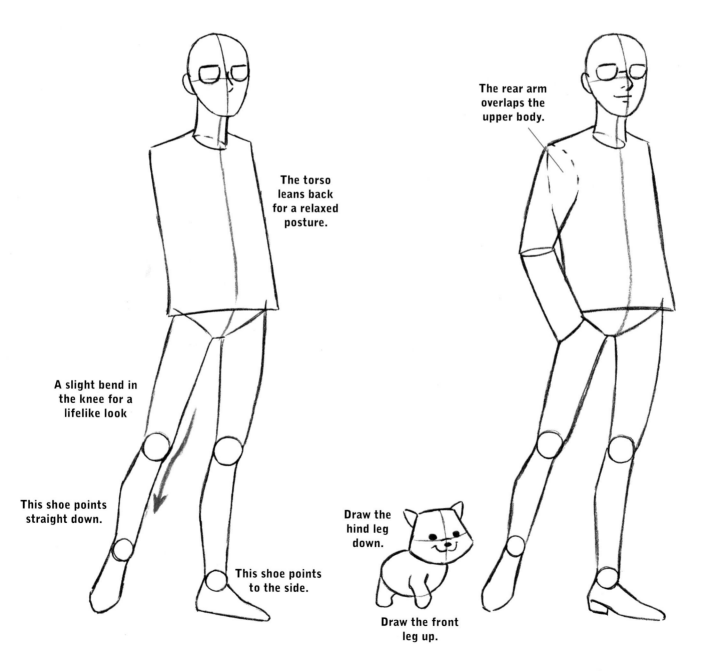

The rear arm overlaps the upper body.

The torso leans back for a relaxed posture.

A slight bend in the knee for a lifelike look

This shoe points straight down.

This shoe points to the side.

Draw the hind leg down.

Draw the front leg up.

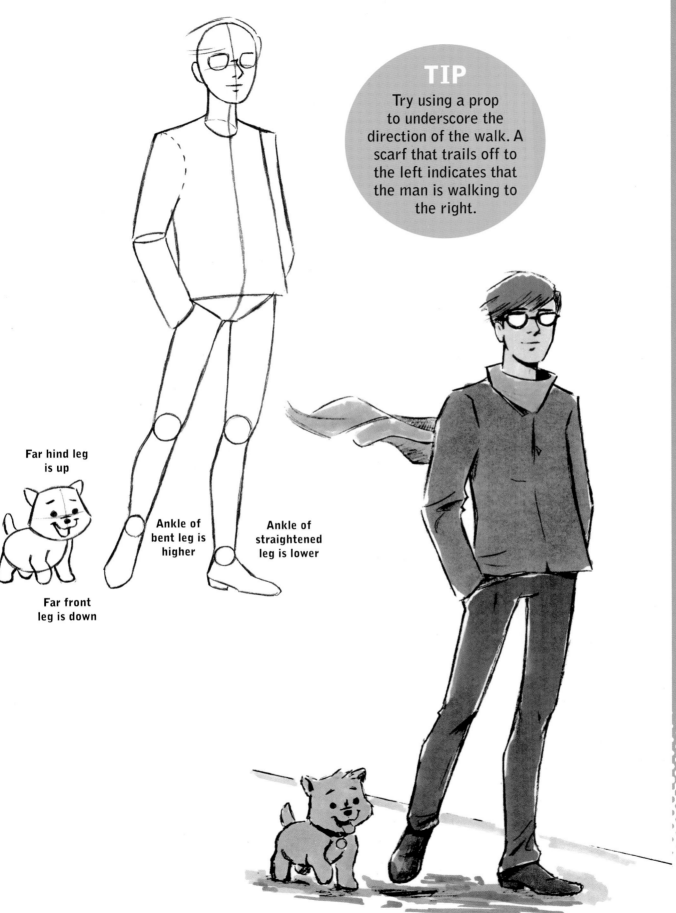

TIP
Try using a prop to underscore the direction of the walk. A scarf that trails off to the left indicates that the man is walking to the right.

Far hind leg is up

Far front leg is down

Ankle of bent leg is higher

Ankle of straightened leg is lower

123

Walking—Side View

Now we turn to the walk in a side view. This is the angle most of us think of when we think of drawing a walking position. There's a common belief—which is not true—that it's important to show the arms flapping forward and back in sync with the legs. But people actually move their arms very little as they walk. Let's draw a natural looking walk with the arms posed so as not to shift position.

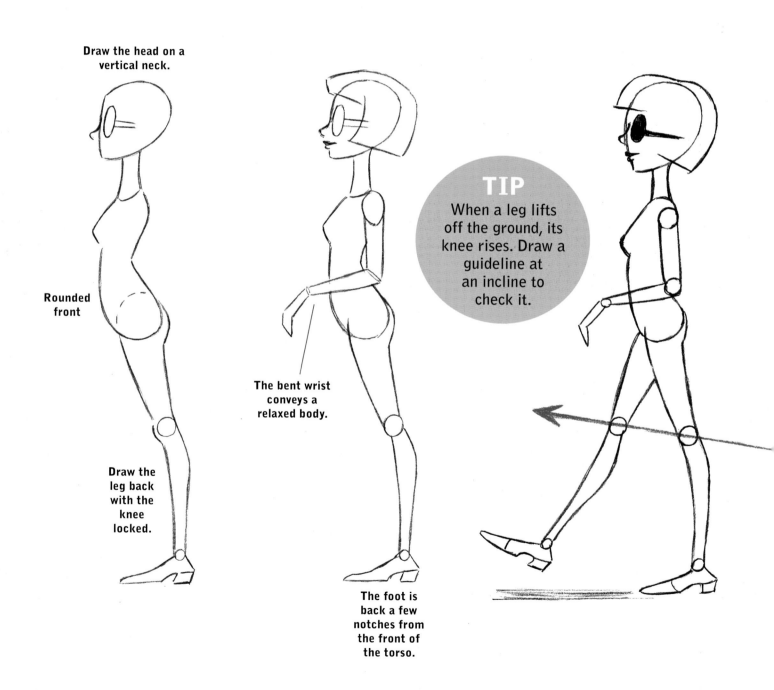

Draw the head on a vertical neck.

Rounded front

Draw the leg back with the knee locked.

The bent wrist conveys a relaxed body.

TIP
When a leg lifts off the ground, its knee rises. Draw a guideline at an incline to check it.

The foot is back a few notches from the front of the torso.

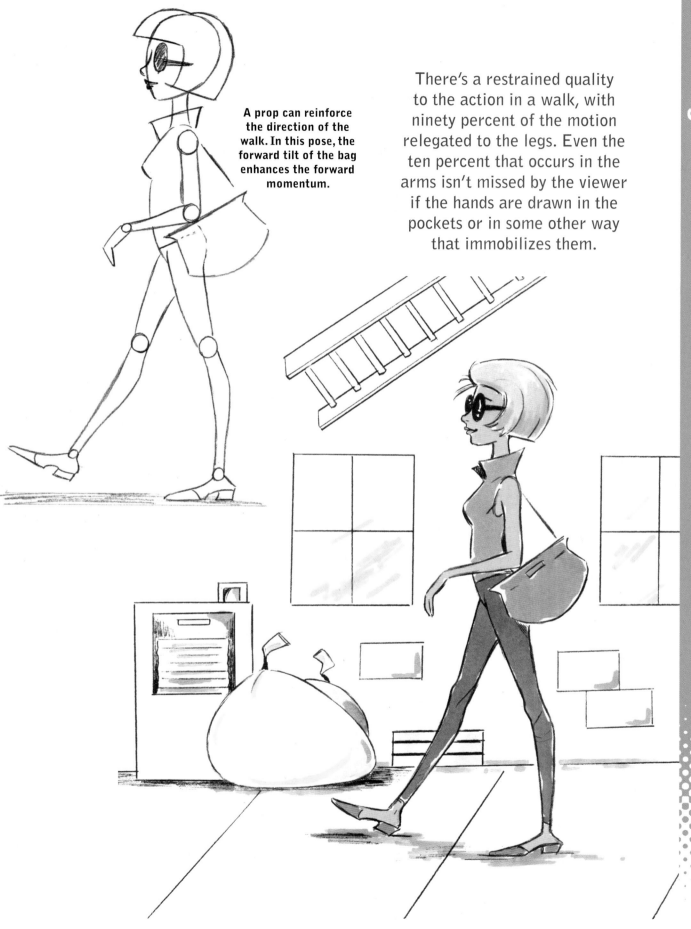

A prop can reinforce the direction of the walk. In this pose, the forward tilt of the bag enhances the forward momentum.

There's a restrained quality to the action in a walk, with ninety percent of the motion relegated to the legs. Even the ten percent that occurs in the arms isn't missed by the viewer if the hands are drawn in the pockets or in some other way that immobilizes them.

Drawing Clothes

A fashionable outfit will enhance the look of your figure drawings. It can transform a well-drawn figure into something eye-popping. A dramatic outfit also allows you to push the pose a little further. In this chapter, we'll continue our focus on figure drawing, but we'll also learn important tips for drawing attractive outfits.

About Sketching

In my experience helping aspiring artists, I've found that the majority of them work hard to avoid mistakes. They should be doing just the opposite. If you want to learn to draw, make *more* mistakes. Trying out ideas is the basis of drawing, even if your ideas don't always work. So take it easy, and erase as much as you like.

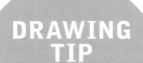

DRAWING TIP

If you don't make mistakes, you're not learning.

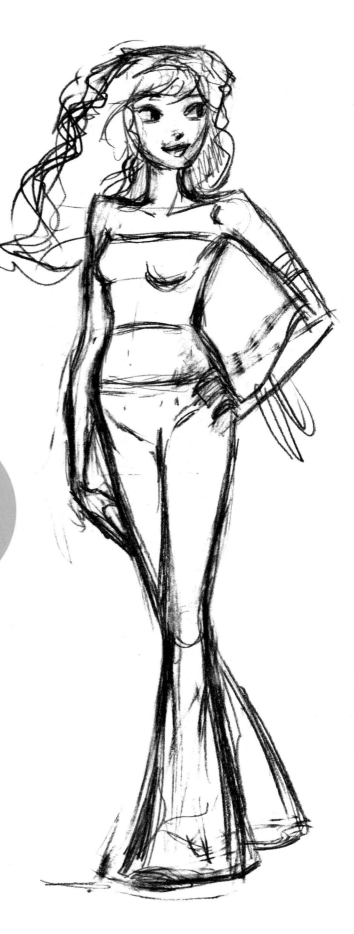

Leave Some Drawings Rough

There's no law saying you have to clean up and finish every drawing you do. Rough drawings, called *roughs,* have a special vitality. It's cool to see a few false starts buried within a drawing. Therefore, continue to create your finished drawings, but if something looks good to you in rough form, leave it. That may be part of its appeal.

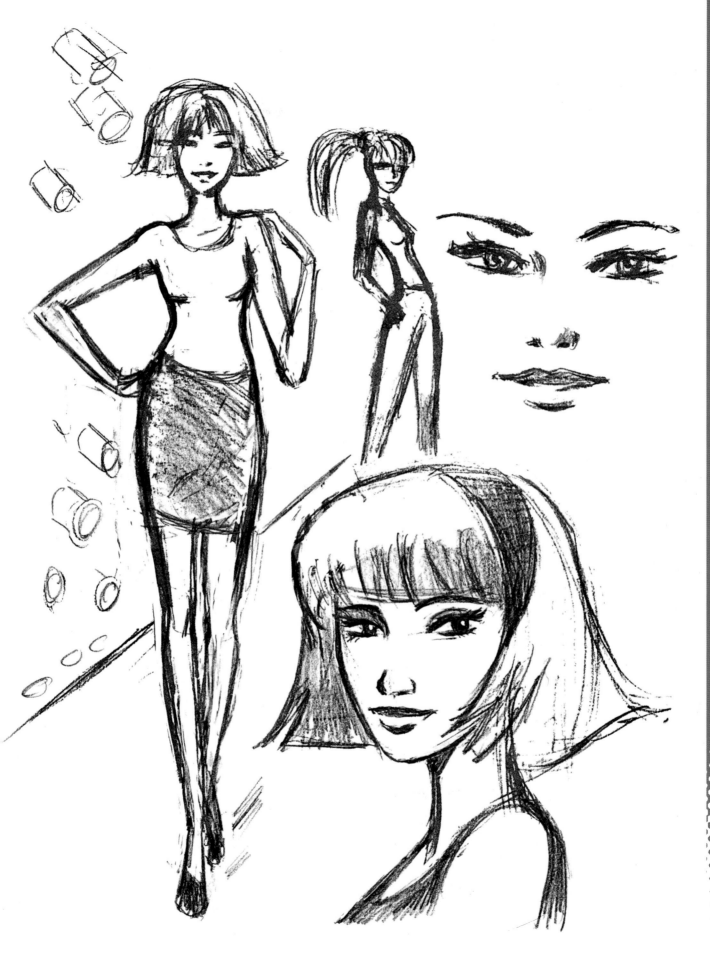

Stylish Dress

The cut of the dress is at least as important as the pattern that may be printed on it. This dress, for example, has no pattern whatsoever, yet it's still stylish and appealing. This urban-chic dress is a minimalistic look.

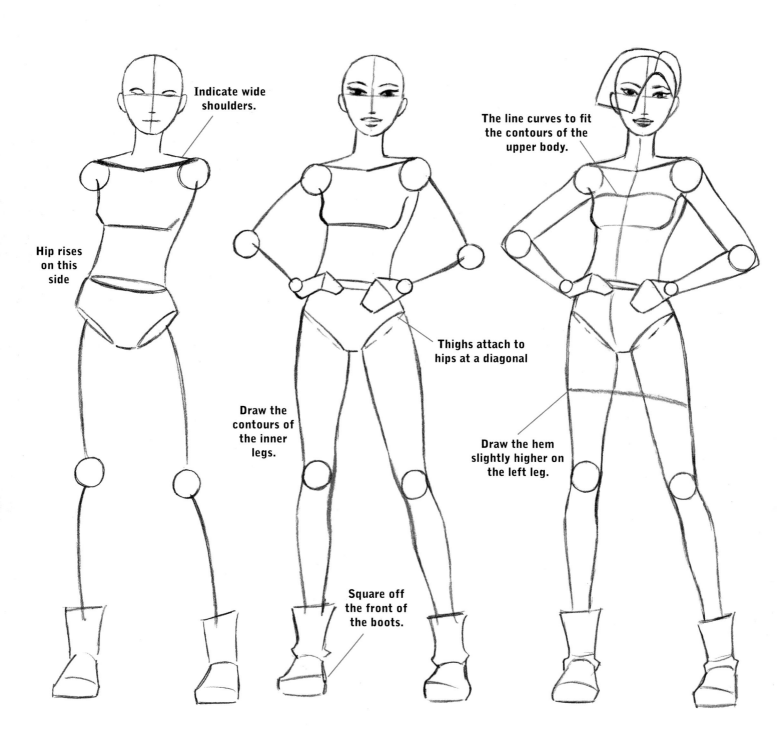

Indicate wide shoulders.

Hip rises on this side

Draw the contours of the inner legs.

Thighs attach to hips at a diagonal

The line curves to fit the contours of the upper body.

Draw the hem slightly higher on the left leg.

Square off the front of the boots.

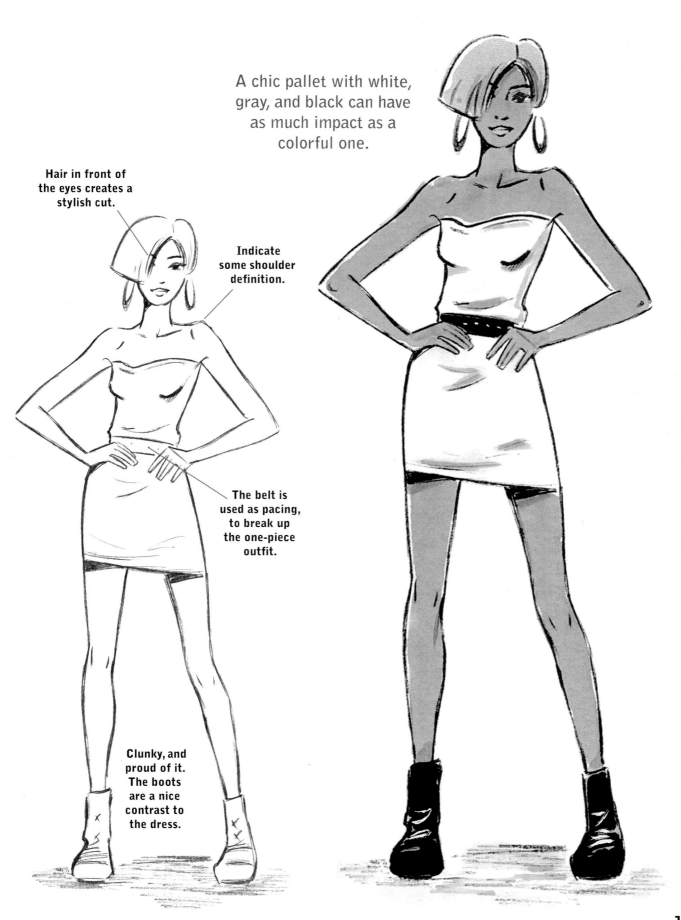

A chic pallet with white, gray, and black can have as much impact as a colorful one.

Hair in front of the eyes creates a stylish cut.

Indicate some shoulder definition.

The belt is used as pacing, to break up the one-piece outfit.

Clunky, and proud of it. The boots are a nice contrast to the dress.

Pants and a Blazer

This is seasonal fashion. The hairstyle is as stylish as the outfit. Now, take a look at the jacket. Jackets may look challenging to draw, but there's a trick to them that makes it easy. I'll point it out in step 2 below.

Overlap creates a sense of solidity.

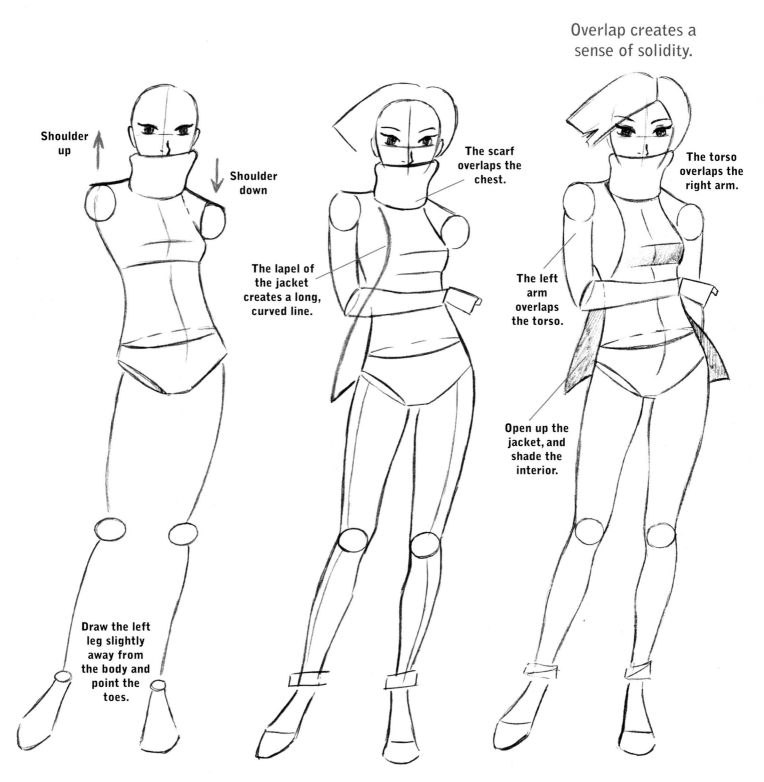

Shoulder up

Shoulder down

The scarf overlaps the chest.

The lapel of the jacket creates a long, curved line.

The torso overlaps the right arm.

The left arm overlaps the torso.

Open up the jacket, and shade the interior.

Draw the left leg slightly away from the body and point the toes.

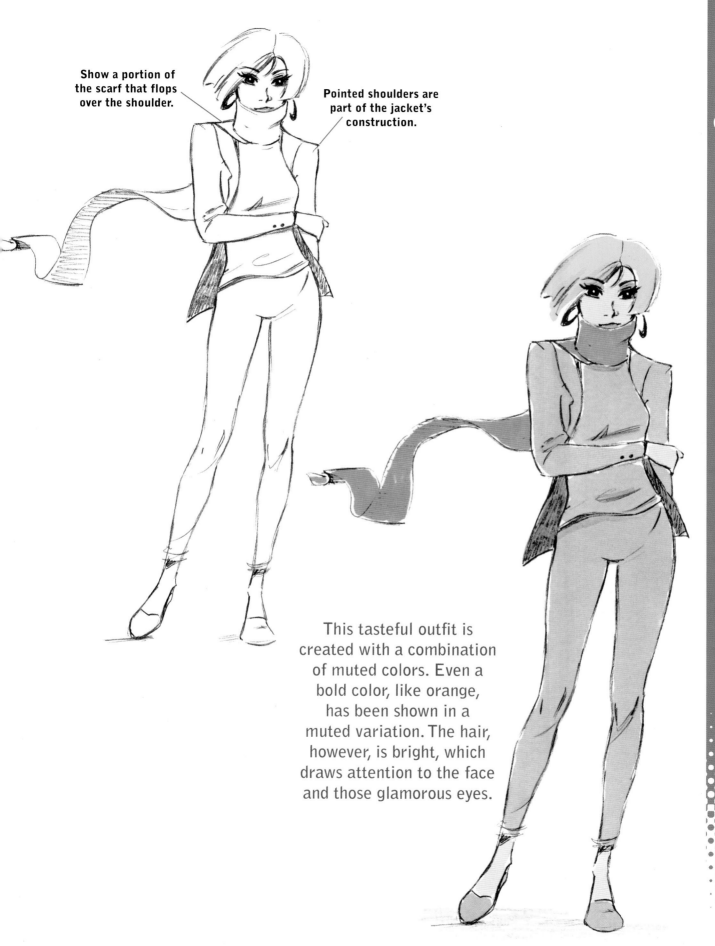

Show a portion of the scarf that flops over the shoulder.

Pointed shoulders are part of the jacket's construction.

This tasteful outfit is created with a combination of muted colors. Even a bold color, like orange, has been shown in a muted variation. The hair, however, is bright, which draws attention to the face and those glamorous eyes.

High-End Clothing

When drawing outfits for your figures, tasteful, well-tailored clothing is never a mistake. Note how the subdued elegance of the posture matches that of the outfit.

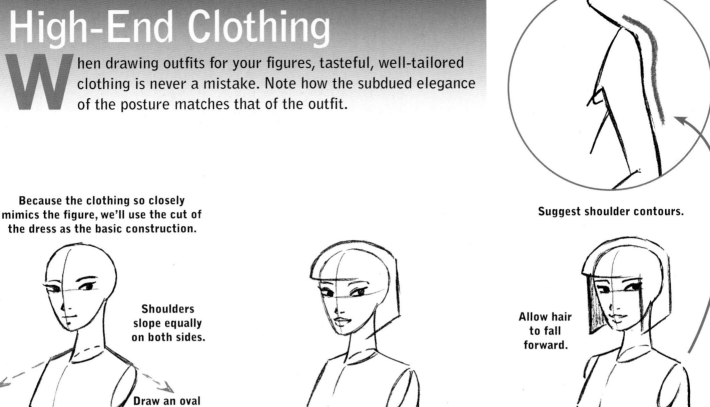

Suggest shoulder contours.

Because the clothing so closely mimics the figure, we'll use the cut of the dress as the basic construction.

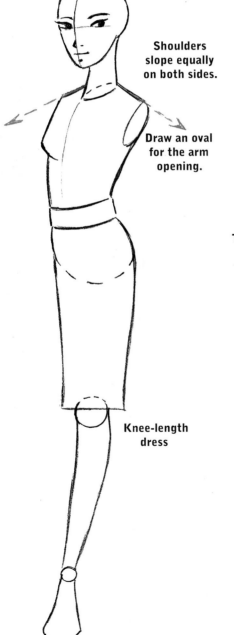

Shoulders slope equally on both sides.

Draw an oval for the arm opening.

Knee-length dress

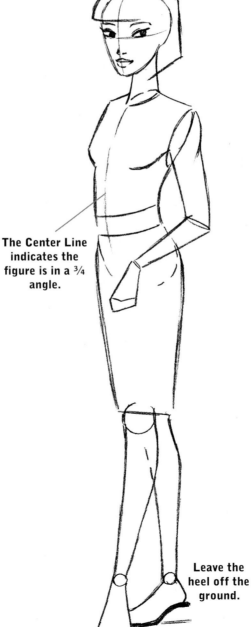

The Center Line indicates the figure is in a ¾ angle.

Leave the heel off the ground.

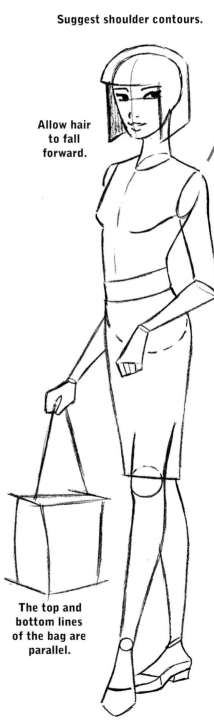

Allow hair to fall forward.

The top and bottom lines of the bag are parallel.

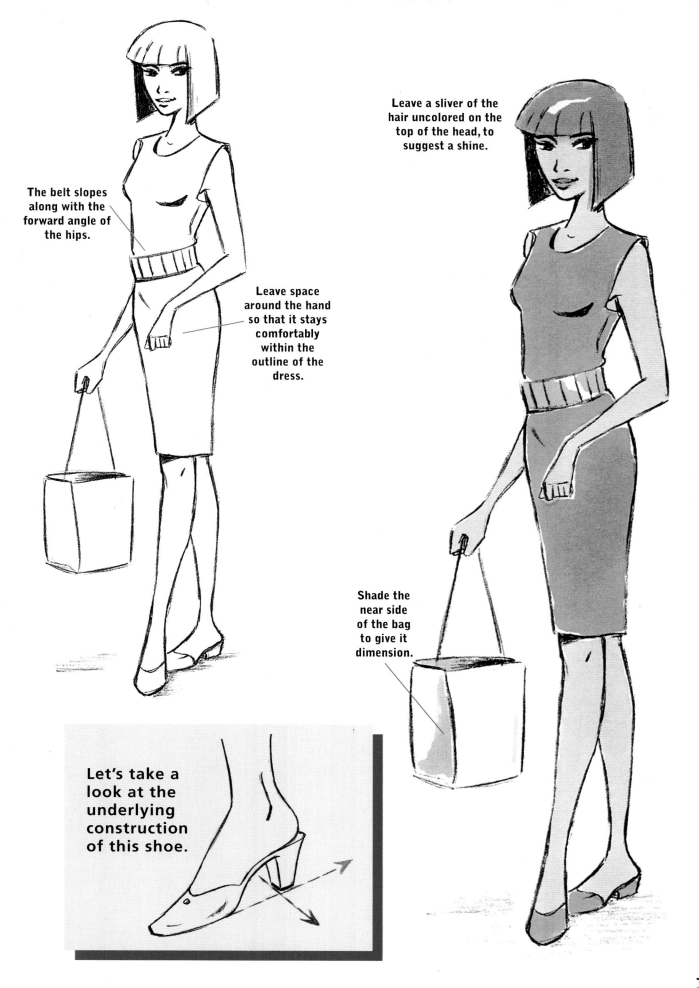

The belt slopes along with the forward angle of the hips.

Leave space around the hand so that it stays comfortably within the outline of the dress.

Leave a sliver of the hair uncolored on the top of the head, to suggest a shine.

Shade the near side of the bag to give it dimension.

Let's take a look at the underlying construction of this shoe.

The Overcoat

An overcoat is a super-fashionable choice. When it works, it's quite dramatic. It spans the length of the figure, and it opens at the bottom to create sweeping lines. But you don't need to open it all the way; the bottom half is all you need. When you open a jacket or overcoat, it suddenly has a flowing quality, which could be just what you're looking for.

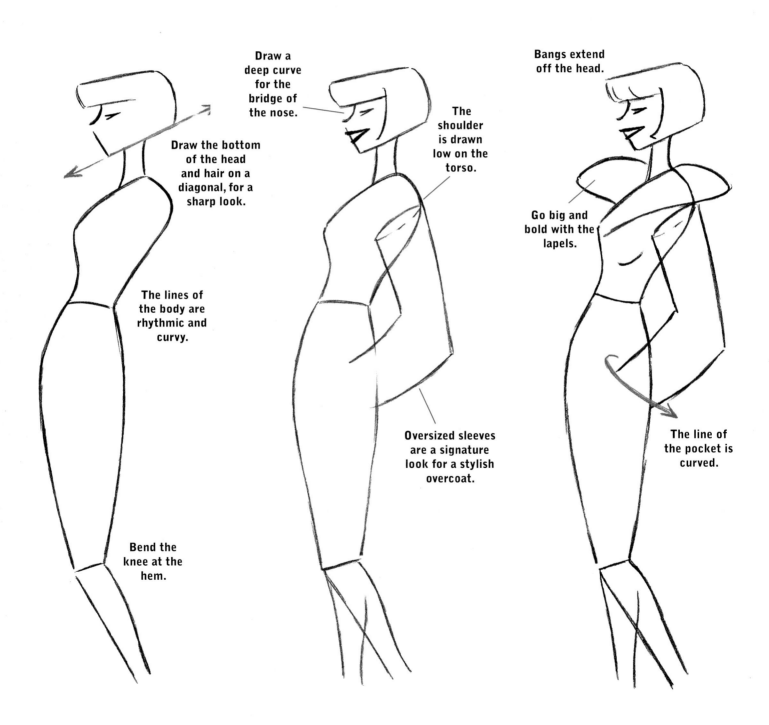

Draw the bottom of the head and hair on a diagonal, for a sharp look.

The lines of the body are rhythmic and curvy.

Bend the knee at the hem.

Draw a deep curve for the bridge of the nose.

The shoulder is drawn low on the torso.

Oversized sleeves are a signature look for a stylish overcoat.

Bangs extend off the head.

Go big and bold with the lapels.

The line of the pocket is curved.

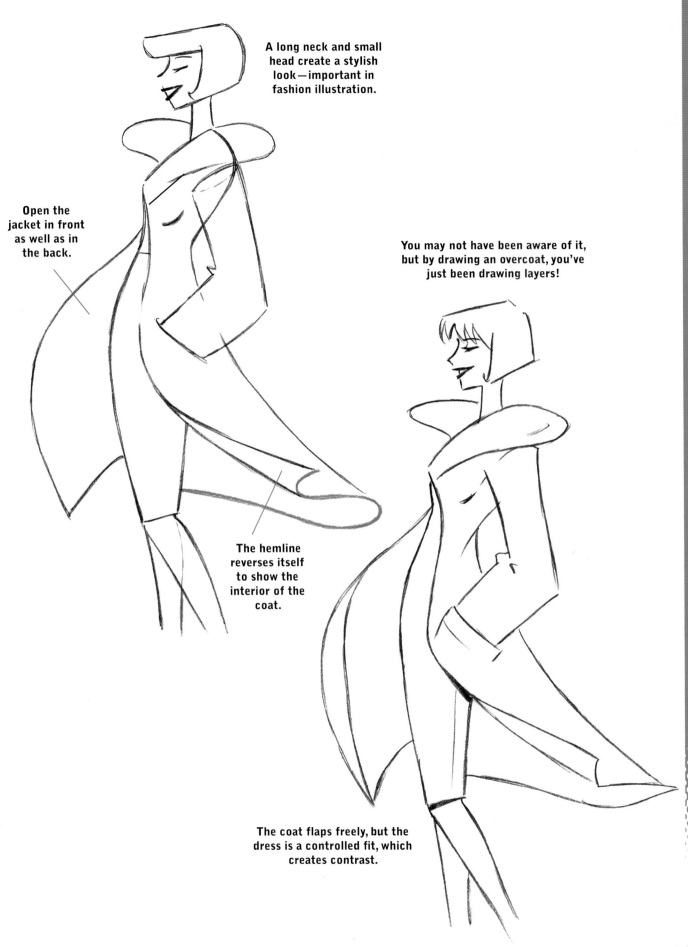

A long neck and small head create a stylish look—important in fashion illustration.

Open the jacket in front as well as in the back.

You may not have been aware of it, but by drawing an overcoat, you've just been drawing layers!

The hemline reverses itself to show the interior of the coat.

The coat flaps freely, but the dress is a controlled fit, which creates contrast.

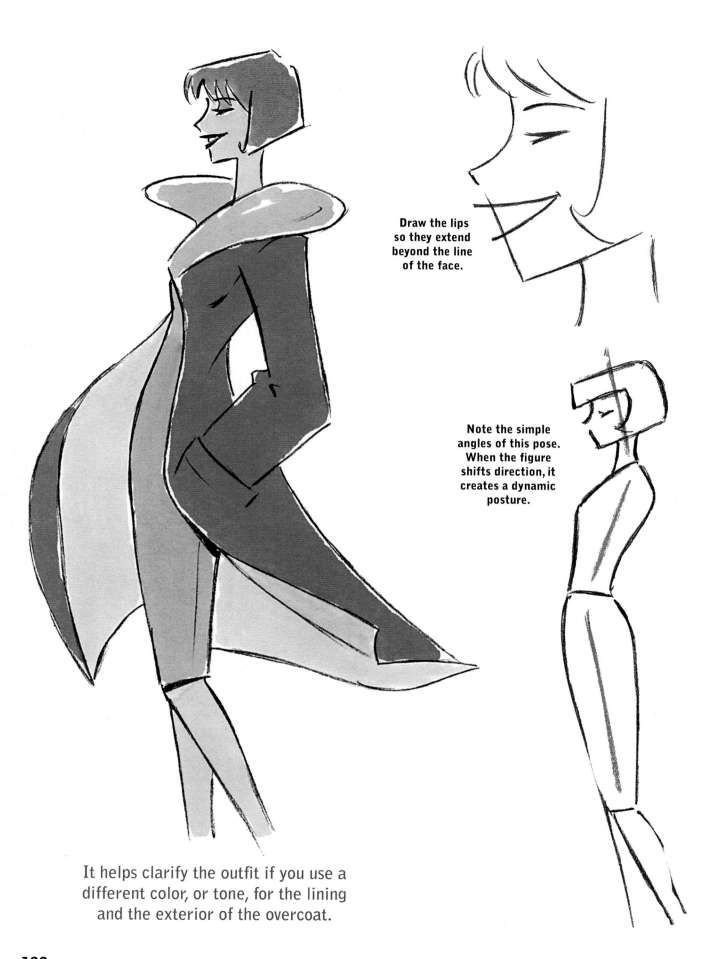

Draw the lips so they extend beyond the line of the face.

Note the simple angles of this pose. When the figure shifts direction, it creates a dynamic posture.

It helps clarify the outfit if you use a different color, or tone, for the lining and the exterior of the overcoat.

Bell Dress

The popular bell dress is an interesting construction: form fitting on top, wide at the bottom. It's a summery, breezy outfit. And because the dress is so wide, we don't need to begin by drawing the complete figure. Instead, we can start with the shape of the dress.

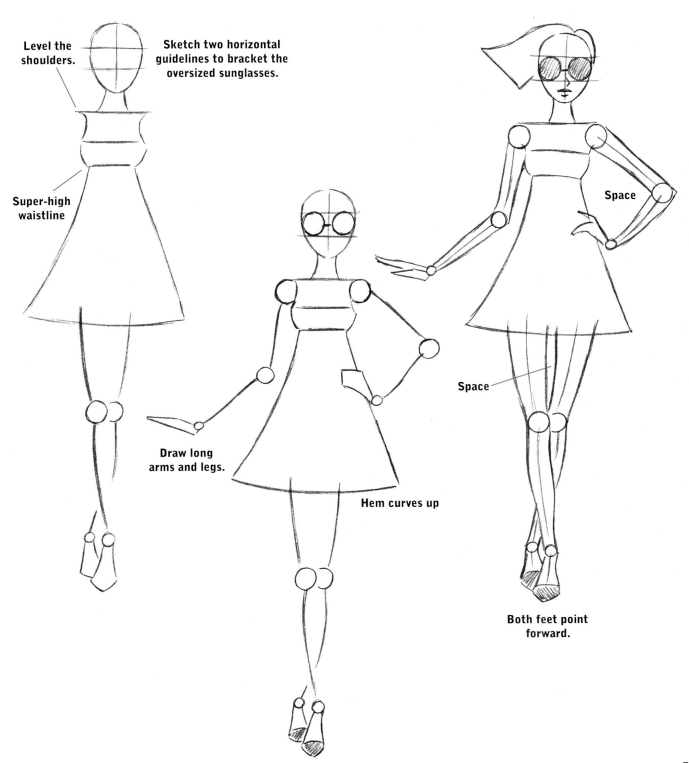

Level the shoulders.

Sketch two horizontal guidelines to bracket the oversized sunglasses.

Super-high waistline

Draw long arms and legs.

Hem curves up

Space

Space

Both feet point forward.

139

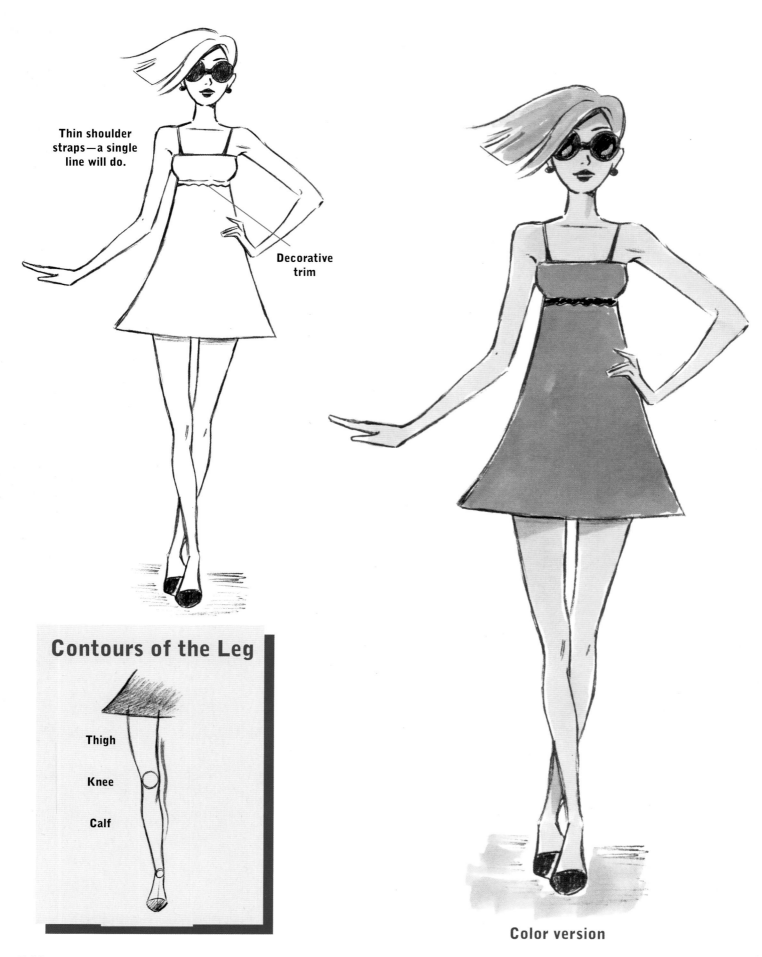

Thin shoulder straps—a single line will do.

Decorative trim

Contours of the Leg

Thigh

Knee

Calf

Color version

Color Thumbnails

Thumbnails is the term used by artists for making rough samples as part of the selection process. Most people think of thumbnails as black and white drawings. But they're incredibly helpful for trying out colors, too. Thumbnails help you figure out the colors for your finished drawings.

Some muted color alternatives

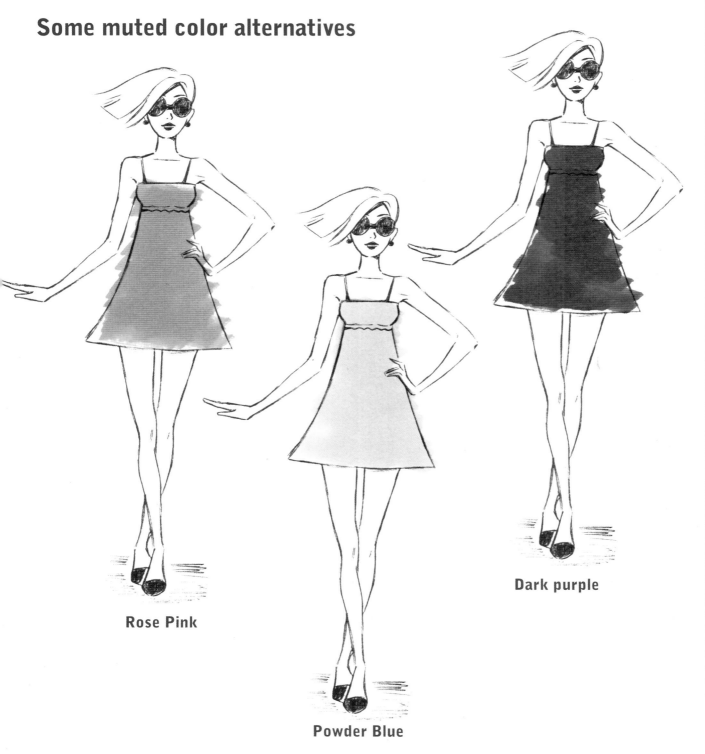

Rose Pink

Powder Blue

Dark purple

Index

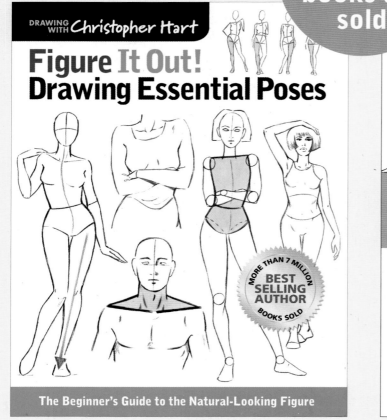
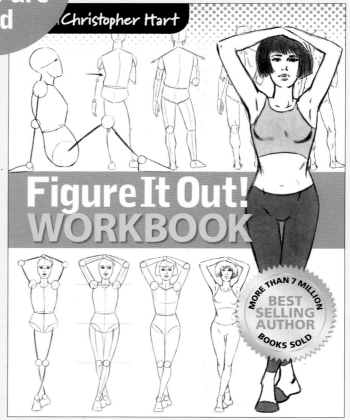